THE SPIRIT OF SAILING

A CELEBRATION OF SEA AND SAIL

BY

MICHAEL KAHN

COURAGE
BOOKS

AN IMPRINT OF RUNNING PRESS
PHILADELPHIA · LONDON

9 8 7 6 5 4 3 2 1
Digit on the right indicates the number of this printing

Library of Congress Cataloging-in-
Publication Number 2003110220

ISBN 0-7624-1774-9

Cover and interior design by Serrin Bodmer
Research by Melissa Eppolito

This book may be ordered by mail from the publisher.
But try your bookstore first!

Published by Courage Books, an imprint of
Running Press Book Publishers
125 South Twenty-second Street
Philadelphia, Pennsylvania 19103-4399

Visit us on the web!
www.runningpress.com

INTRODUCTION

BOATS

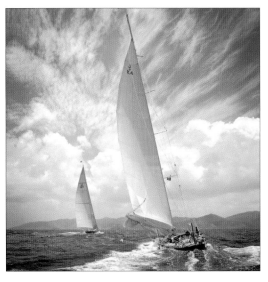

THE SEA AND SAILING

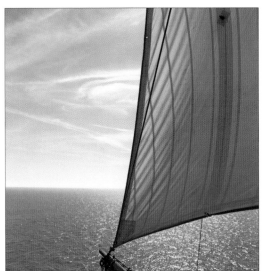

CONTENTS

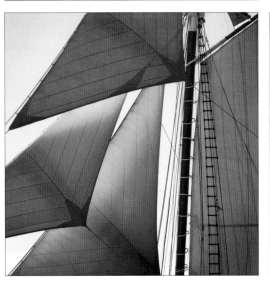

THE WIND

INTRODUCTION

SURFING PAST THE BUOYS THAT MARKED the channel, I aimed the bow towards the crashing breakers on the sand bar that separated the sound from the ocean. I sheeted in the mainsail and hiked out further to meet the onshore breeze. "Time them," I said to myself, "time the swells and look for the opening." Seeing the pattern I raised the centerboard, crossed the bar, and sailed into the Atlantic, leaving the encumbrances of the shore behind. These were my first sailing memories, on Topsail Island, North Carolina. Blackbeard the Pirate named the Island "Topsail" because his ship would lay behind the dunes with its sails down, waiting for a glimpse of the topsails from unsuspecting ships passing by the coast. It was off Topsail Island that as a child I learned to sail—a child with a yellow sunfish named Lemon Drop, dreaming of pirates and great ships.

I received my first camera at age thirteen. A gift from my mother, I promptly soaked it when my canoe overturned in a northern Ontario lake. When I returned home, my neighbor loaned me a German-made 35mm camera. The camera was far more technically advanced than I was at the time, but I still remember the clarity and contrast of those first rolls of black-and-white film that I processed in the high school darkrooms. The magic of seeing the image develop in the trays, under the red safelight, has never left me. This is how my love for photography was born.

My two passions, sailing and photography, came together in 1995 when I was invited to vacation on a lake in the Adirondack Mountains in New York. It was here that I came across a boat so beautiful in shape I felt compelled to photograph her. One foggy morning as the sun rose, I rowed a homemade boat to where the one hundred-year-old sloops were moored. There, waiting for my wake to settle and the mirror-like reflections to return, I began shooting roll after roll of these magnificent boats. Sometimes my composition showed just a little piece of the bow with a hint of a pine-covered island scarcely showing through the fog; other times I captured the top of the mast with the sun's halo behind. By later in the day, the serenity of the morning shoot was long forgotten. As the owners of the antique sloops raced around the lake, I would follow them in a powerboat making exposure after exposure. The images I brought back from these races contained sails billowing in the foreground, waves rushing under the hull, and illustrated a counterpoint to the

tranquility of sailing that my morning photographs had captured. My love of sailing and photography had finally come together.

Who were these people so dedicated to keeping a one hundred-year-old boat alive and were able to sail them every chance they had? Were there others like them and where could I find them? In search of the spirit of sailing I went to Maine and found hundreds of people building, restoring, sailing, racing, cruising, and chartering these fantastic old boats. I soon discovered that this was not just a local scene but people all over the world were lovingly caring for all types of hand-crafted boats— from the whimsical Beatlecats to the working schooners and fishing boats, to majestic tall ships and the ultimate sailing machines—J class sloops. I learned that there are museums, regattas, schools, and shipyards dedicated to the education, preservation, restoration, and creation of the classic sailboat.

For newcomers to sailing, there are training organizations and floating classrooms that not only introduce the pleasures of sailing but also teach structure, teamwork, discipline, and most importantly, build the confidence necessary to take on the challenges of life. There are restoration schools and apprentice shops where you can learn to build your own boat or help rebuild a historically significant boat saving it from ruin. You can sign on as a trainee aboard a square-rigger and learn what it is like—first-hand—to sail a tall ship. Many seacoast towns have built or are in the process of building tall ships for education and goodwill ambassadors to the world.

What makes people so passionate about sailing? Seldom in human history has something as beautiful and functional as the sailboat been created. Sailboats represent the ability of people to work with nature, to harness the power of the wind and endure the strength of the sea. From the steam-bent frames and planks to the miles of rigging, the sailing boat is truly a work of artistic architecture. Rarely has a machine been made that meets the needs of people so perfectly and is as lovely and as graceful as the sailing vessel. As to the romance of sail, few inventions have evoked more art than the great ships fighting through storms and calms. Paintings and poetry, songs and photographs, have all come from our infatuation with the sailboat.

This love affair with the sailboat is not only reserved for the tall ships and prestigious yachts, but is shared with smallest of crafts such as the Herreshoff 12½

and the Beetlecat. These graceful yet sturdy vessels, whose lines are distilled from fishing and working boats, are built purely for the joy of an afternoon romp across the bay or a few laps around a lake—yet the shapes and curves designed into these tiny yachts are miraculous. Perhaps it is just as well that we no longer rely on these boats for transportation or to catch fish or carry cargo. Now we enjoy them as a link to our past and for our pleasure. And pleasurable they are—few moments can match the pure joy of ghosting across a mountain lake or rounding an island and beating the tide.

Perhaps we love sailing for its similitude of life itself—the memories of the storms and fog soon fade when the sun comes out and the wind blows fair. The world is in love with sailing and it is for this love that I have made this collection of photographs. This book is a celebration of the joy of sailing and a salute to the preservation efforts of the passionate and dedicated people who perpetuate the spirit of sailing.

—Michael Kahn
July 16, 2003, on board the *Arabella*
Nantucket Sound, Massachusetts

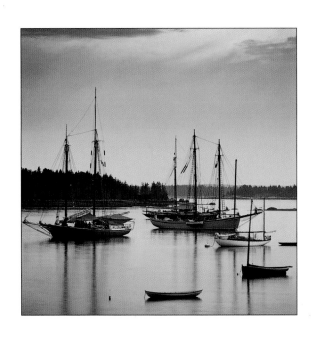

BOATS

BELIEVE ME, MY YOUNG FRIEND,

THERE IS NOTHING—ABSOLUTELY

NOTHING—HALF SO MUCH WORTH

messing about

DOING AS SIMPLY MESSING ABOUT IN BOATS.

—From *The Wind in the Willows*
Kenneth Grahame (1859–1932)
British writer

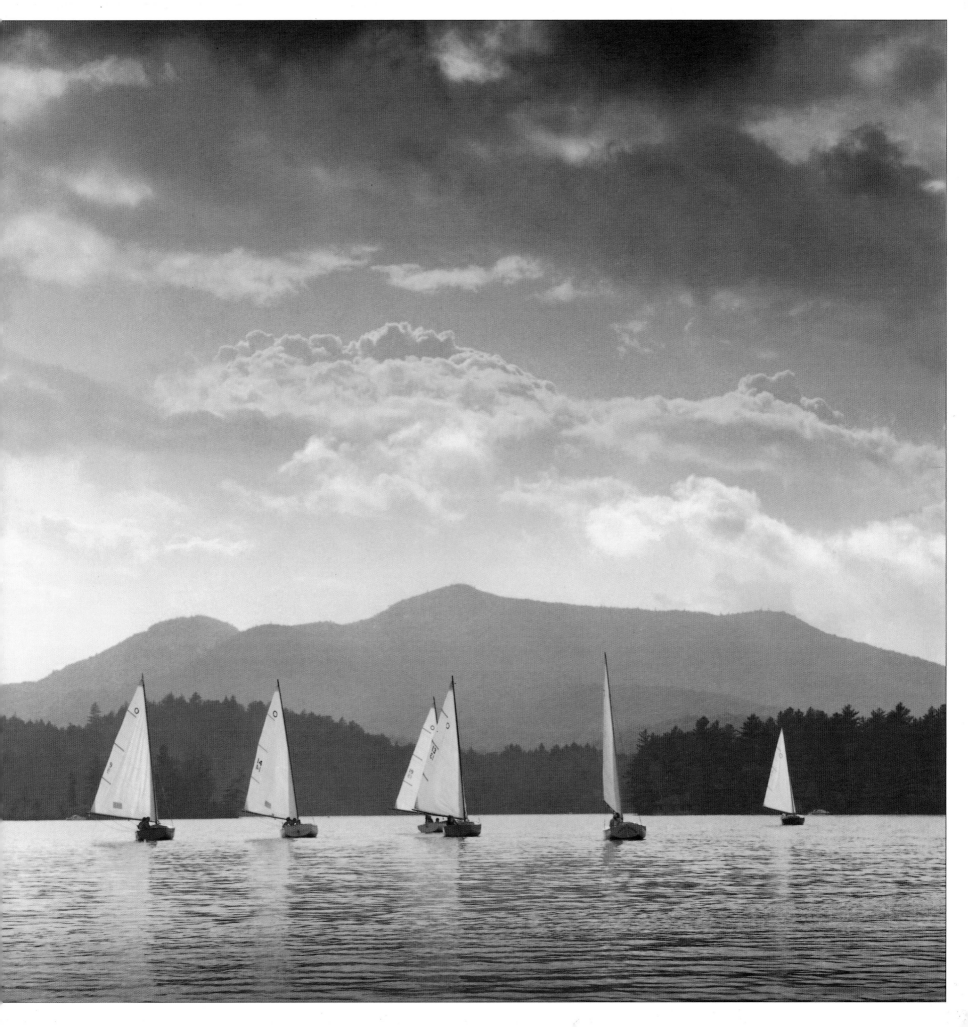

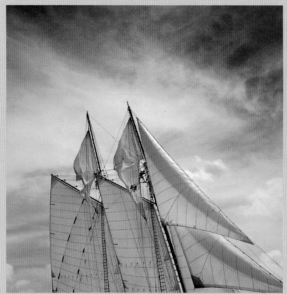

Ships are the nearest things to dreams that hands have ever made.

— FROM "SHIPS"
ROBERT N. ROSE

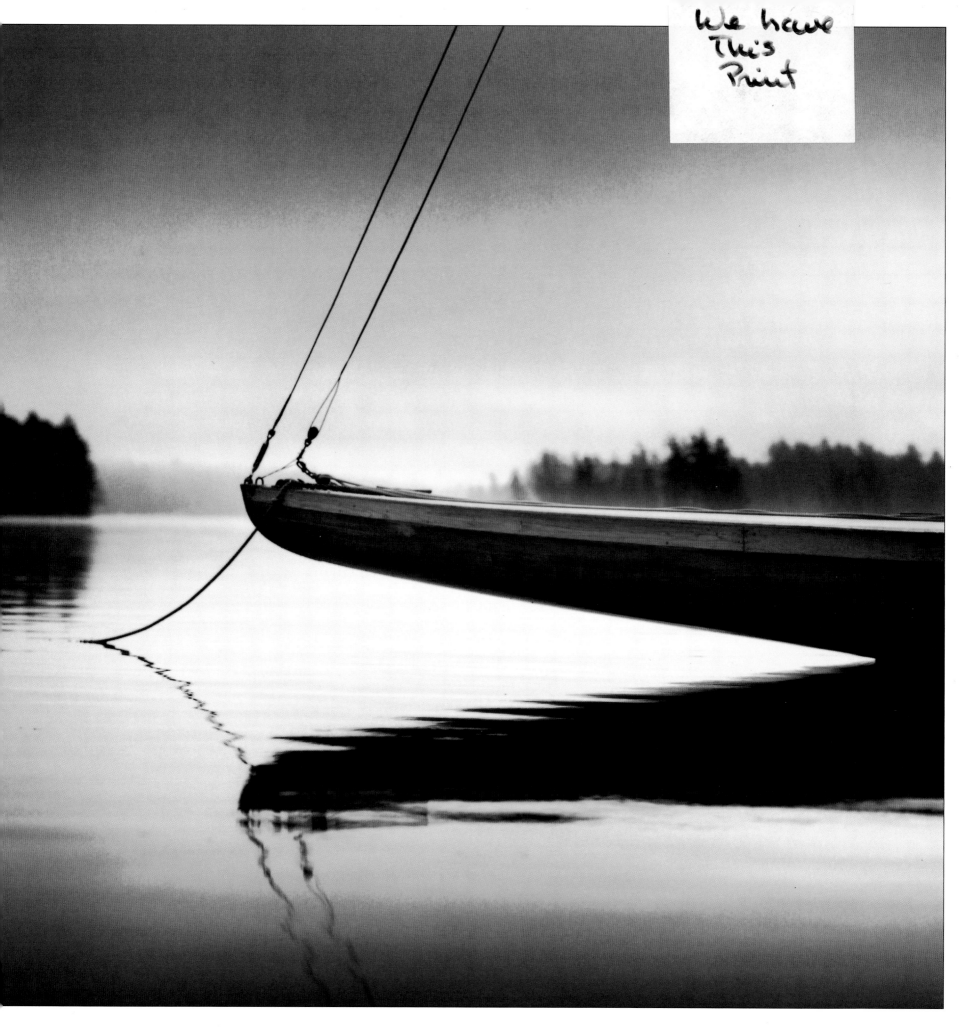

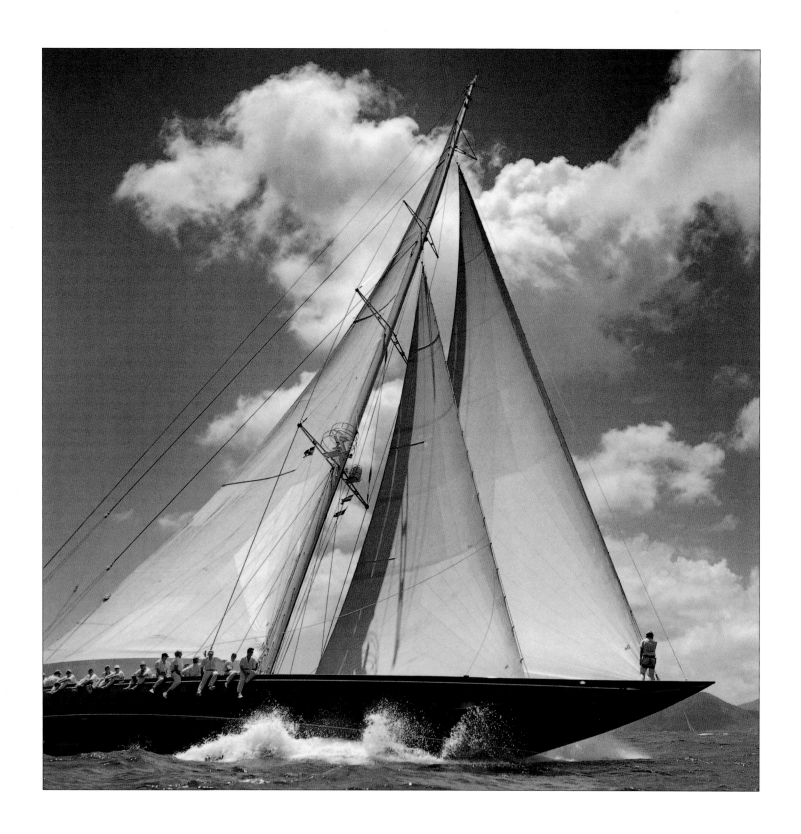

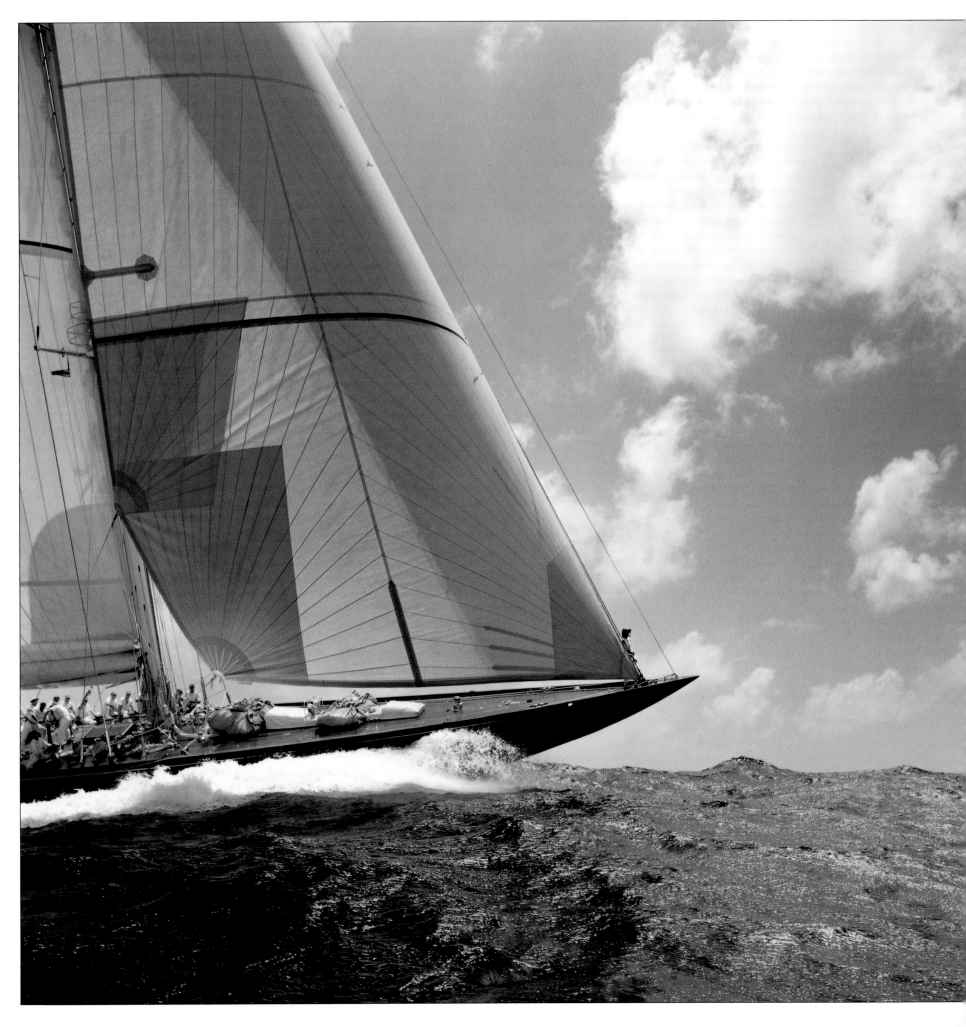

These great and beautiful ships,

 imperceptibly rocking like waddling ducks

on tranquil waters, these robust ships,

 with their idle and nostalgic air,

aren't they telling us in a silent tongue:

 When are we leaving for happiness?

CHARLES BAUDELAIRE
(1821–1867)
FRENCH POET

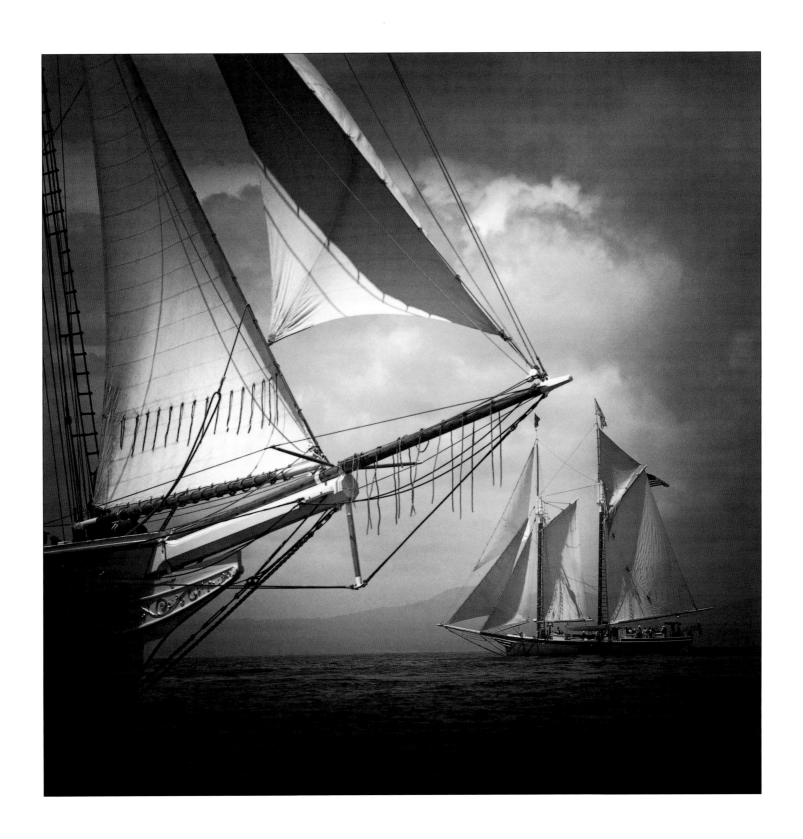

I send thee a shell from the ocean beach;

But listen thou well, for my shell hath speech.

Hold to thine ear,

And plain thou'lt hear

Tales of ships . . .

—FROM "WITH A NANTUCKET SHELL"
CHARLES HENRY WEBB (1834–1905)
AMERICAN JOURNALIST AND POET

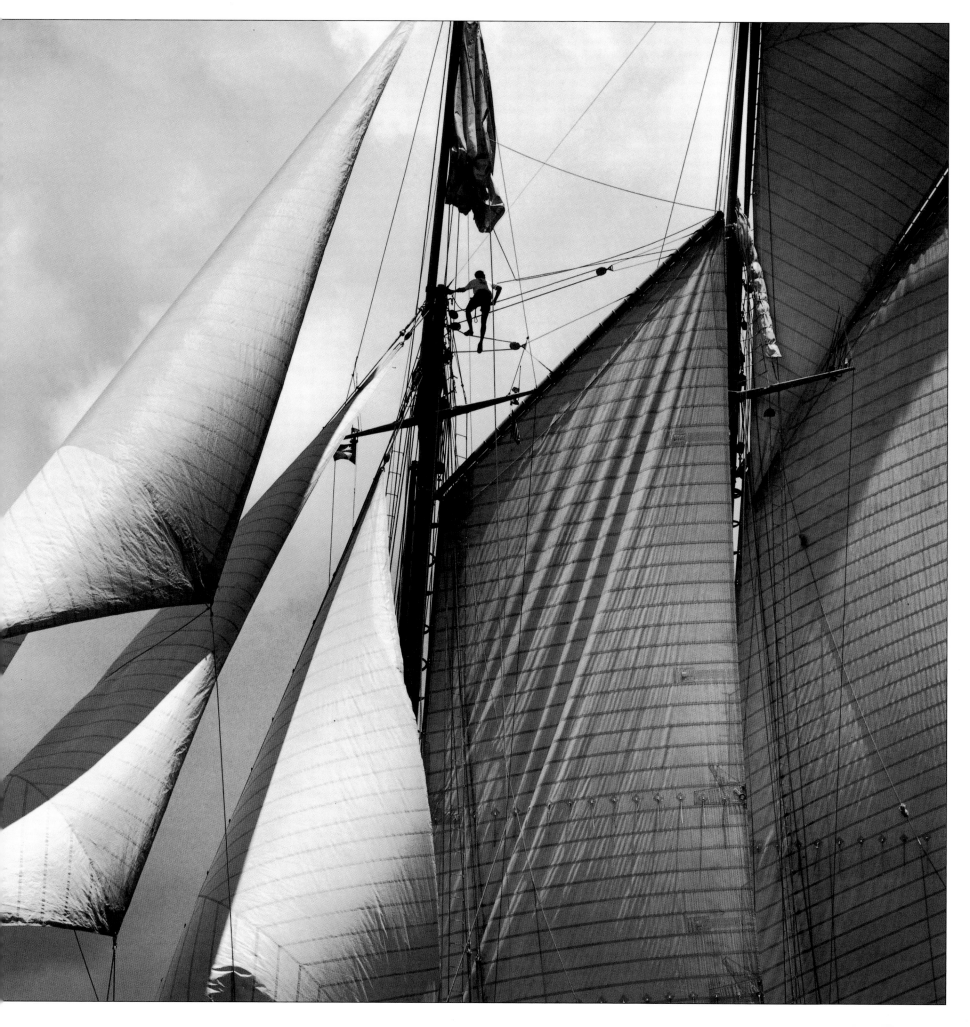

TO ME, NOTHING MADE BY MAN IS MORE BEAUTIFUL

THAN A SAILBOAT UNDER WAY IN FINE WEATHER, AND

TO BE ON THAT SAILBOAT IS TO BE AS CLOSE TO HEAVEN

AS I EXPECT TO GET. IT IS UNALLOYED HAPPINESS.

—ROBERT MANRY (B. 1918)
AMERICAN JOURNALIST AND SAILOR

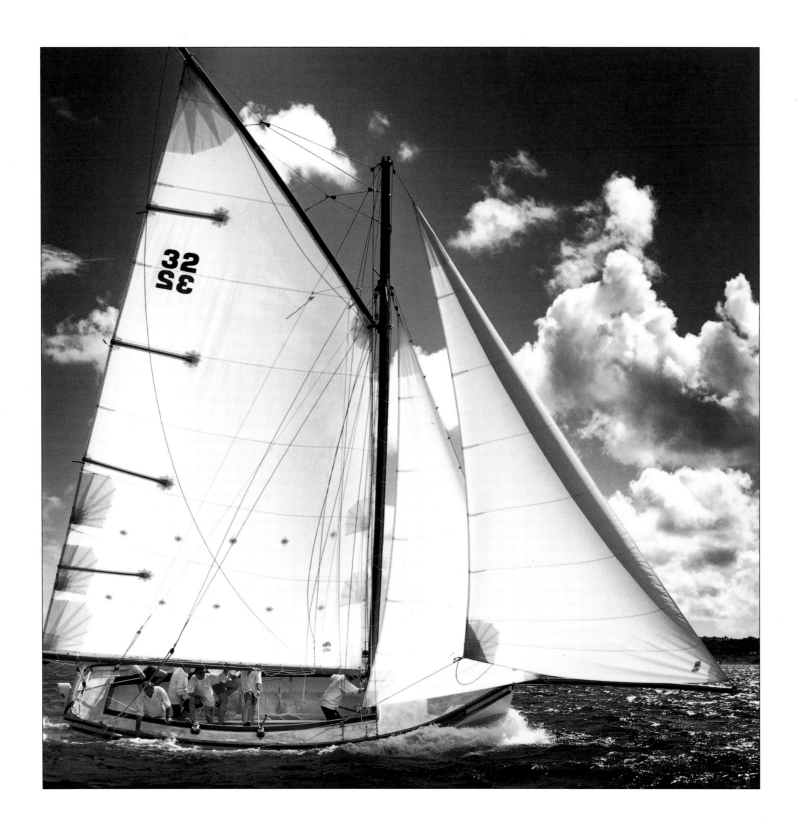

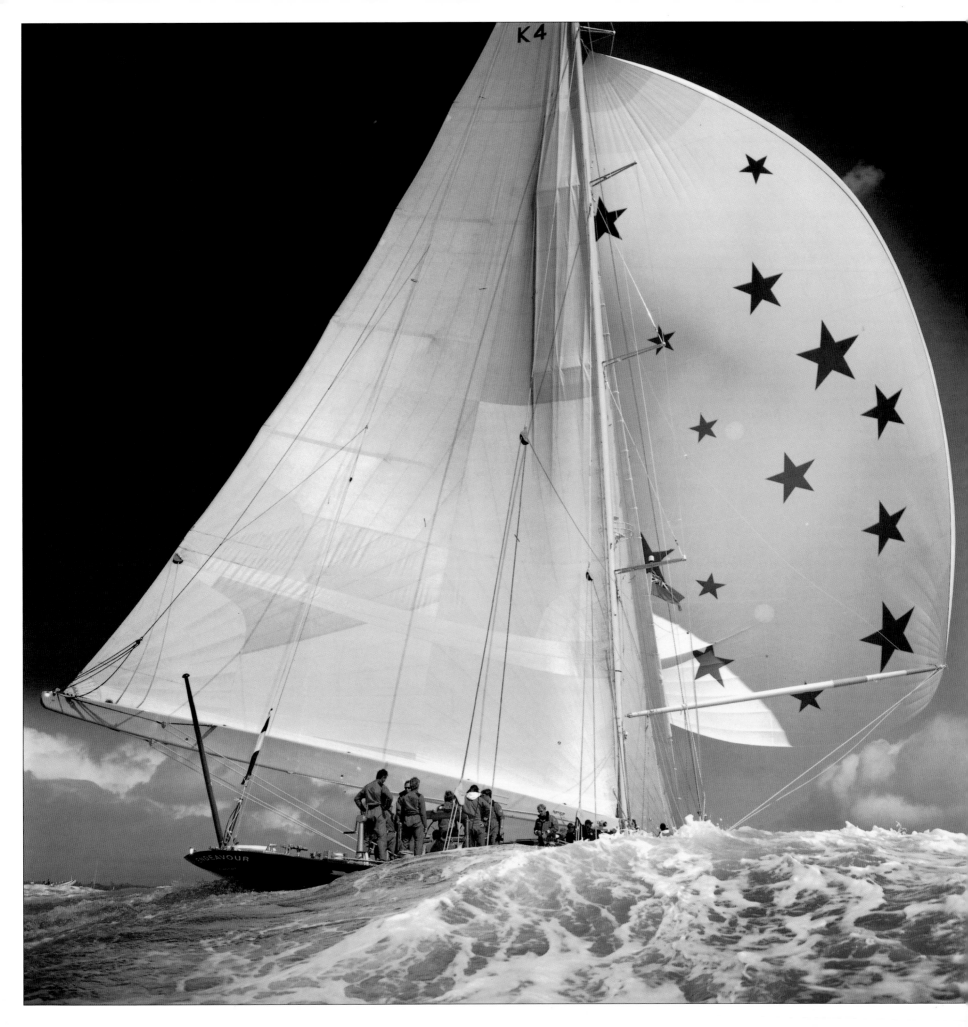

Whe is more pleasant than a friendly little yacht,

a long stretch of smooth water,

a gentle breeze, the stars?

———

WILLIAM ATKIN
(20TH CENTURY)
NAVAL ARCHITECT AND WRITER

———

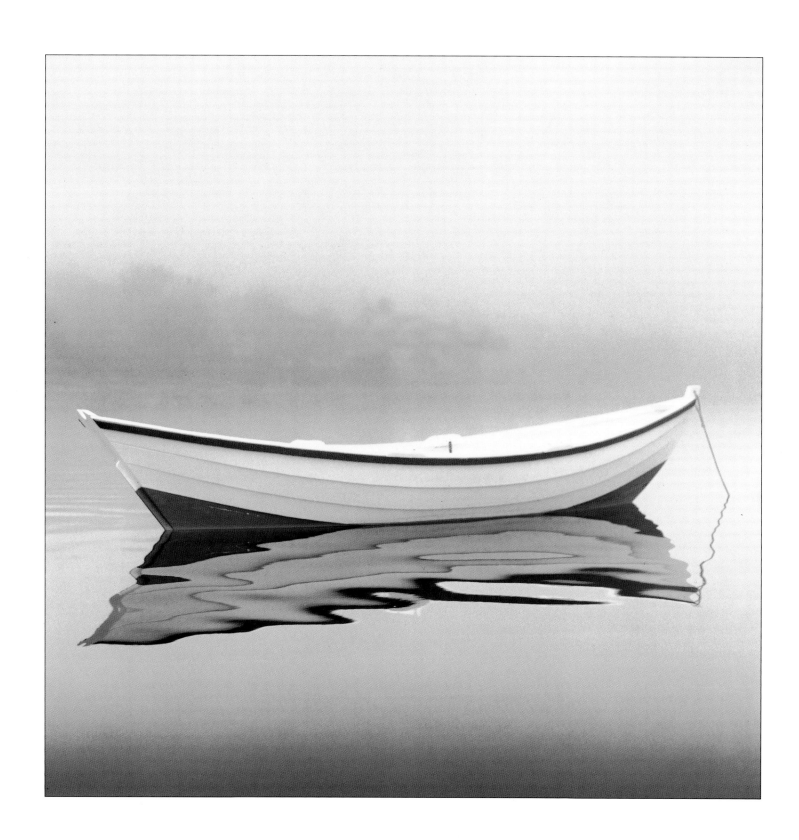

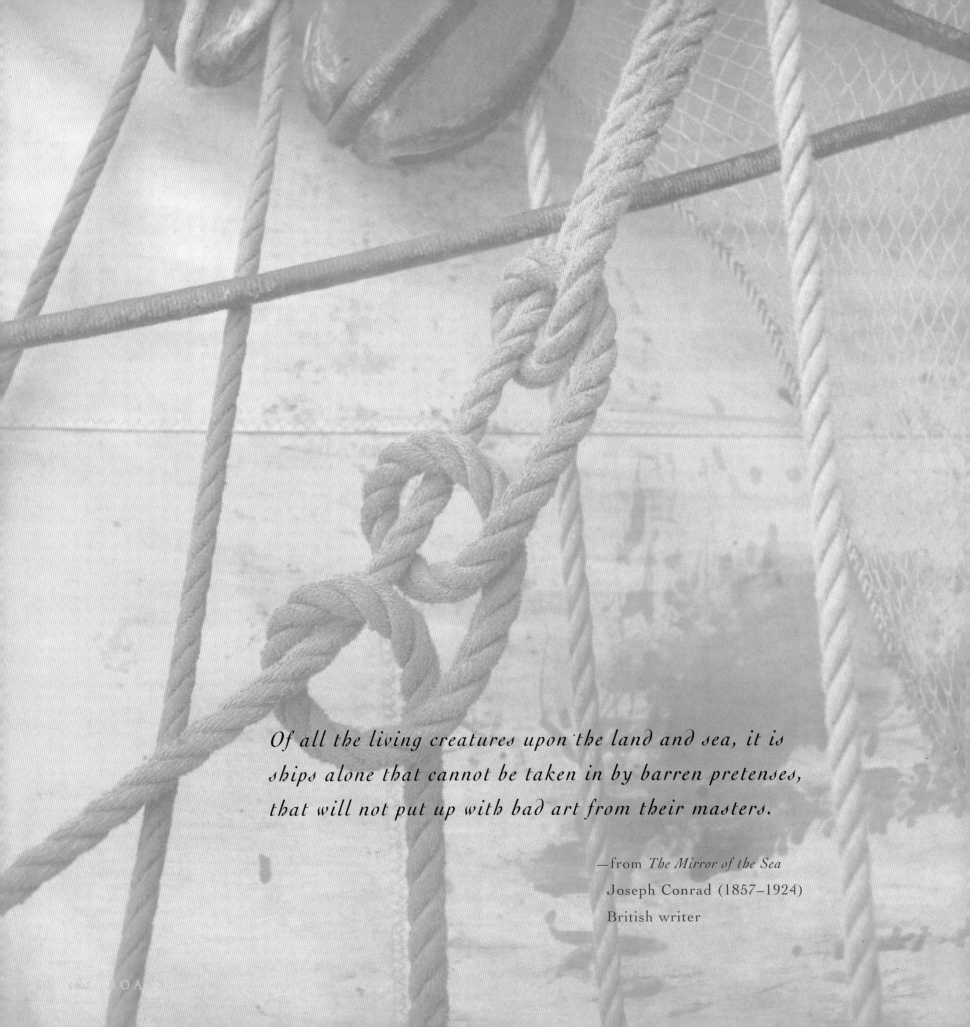

Of all the living creatures upon the land and sea, it is ships alone that cannot be taken in by barren pretenses, that will not put up with bad art from their masters.

—from *The Mirror of the Sea*

Joseph Conrad (1857–1924)

British writer

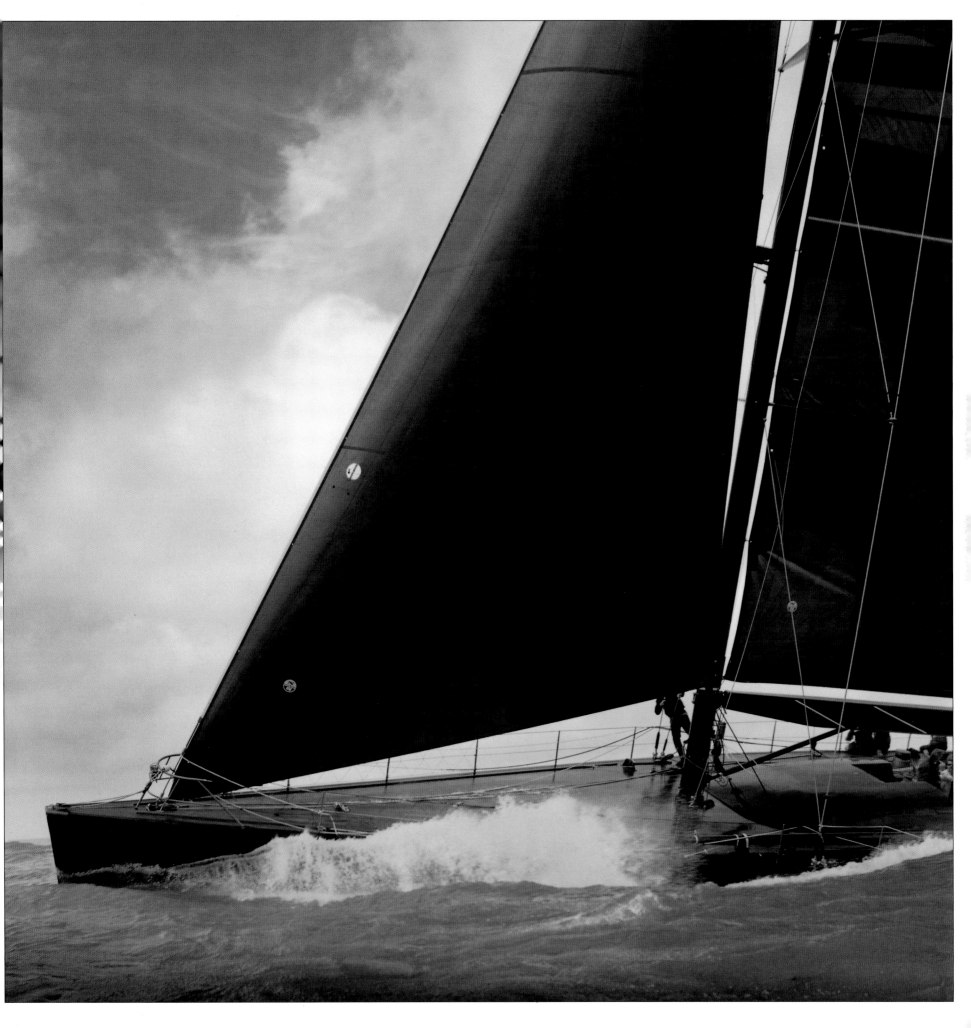

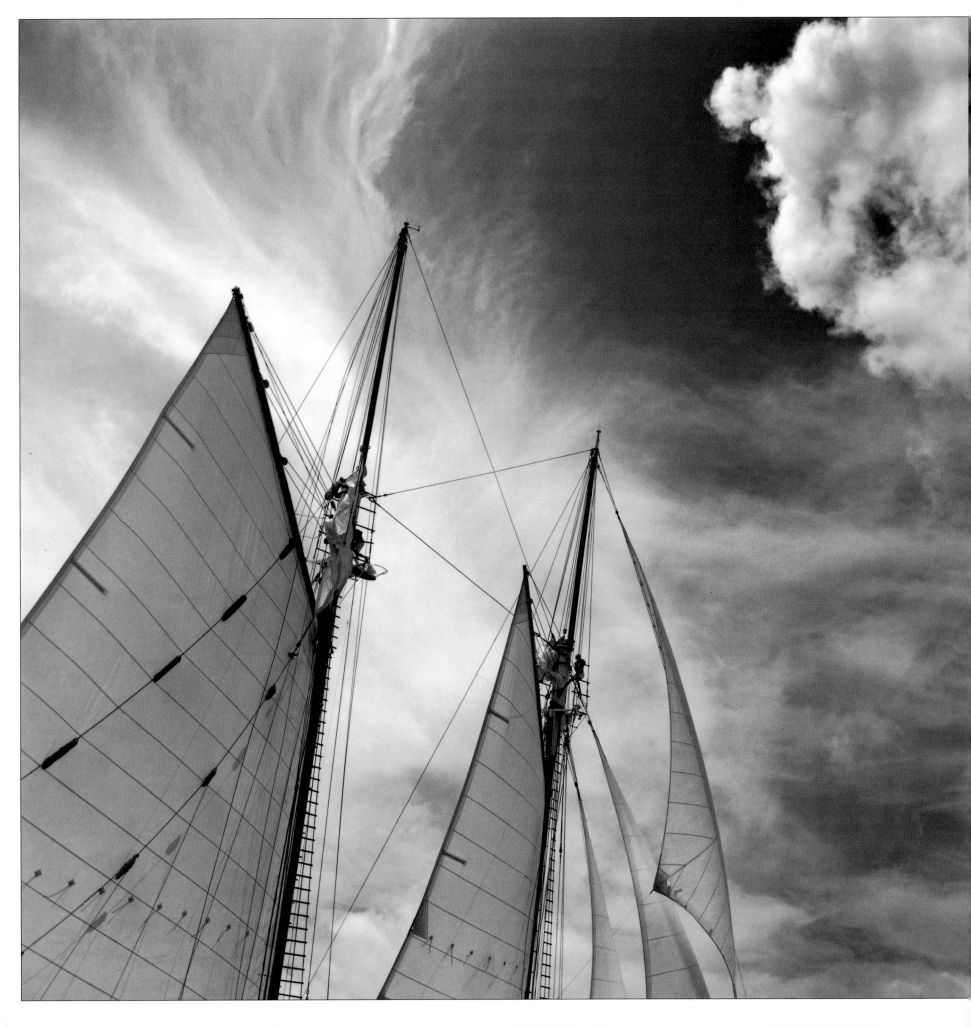

LAST NIGHT I SAW ST. ELMO'S *stars*,

WITH THEIR GLIMMERING LANTERNS, ALL AT PLAY

ON THE TOPS OF THE MASTS AND THE TIPS OF THE SPARS,

AND I KNEW WE SHOULD HAVE FOUL WEATHER TODAY.

—FROM "THE GOLDEN LEGEND"

HENRY WADSWORTH LONGFELLOW (1807–1882)

AMERICAN POET

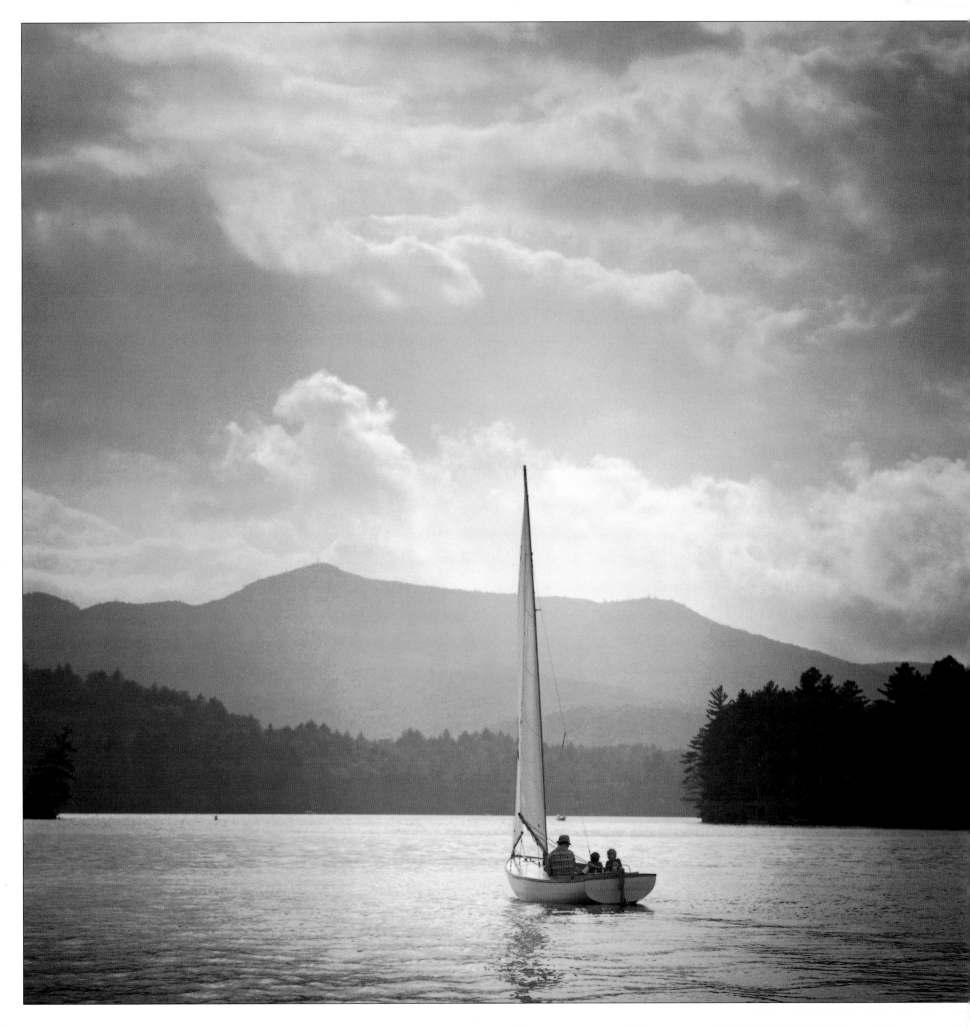

IF A MAN MUST BE OBSESSED BY SOMETHING, I SUPPOSE A BOAT

IS AS GOOD AS ANYTHING, PERHAPS A BIT BETTER THAN MOST.

A SMALL SAILING CRAFT IS NOT ONLY BEAUTIFUL, IT IS SEDUCTIVE

AND FULL OF STRANGE PROMISE AND THE HINT OF TROUBLE.

—FROM *THE SEA AND THE WIND THAT BLOWS*
E.B. WHITE (1899–1985)
AMERICAN WRITER

The sweet lines of some of them all but took my breath away when
I saw them for the first time in all their naked elegance.
I reveled in their good looks and desired them
as much for their beauty as their use.

JOHN GARDNER
(1933–1982)
AMERICAN WRITER AND POET

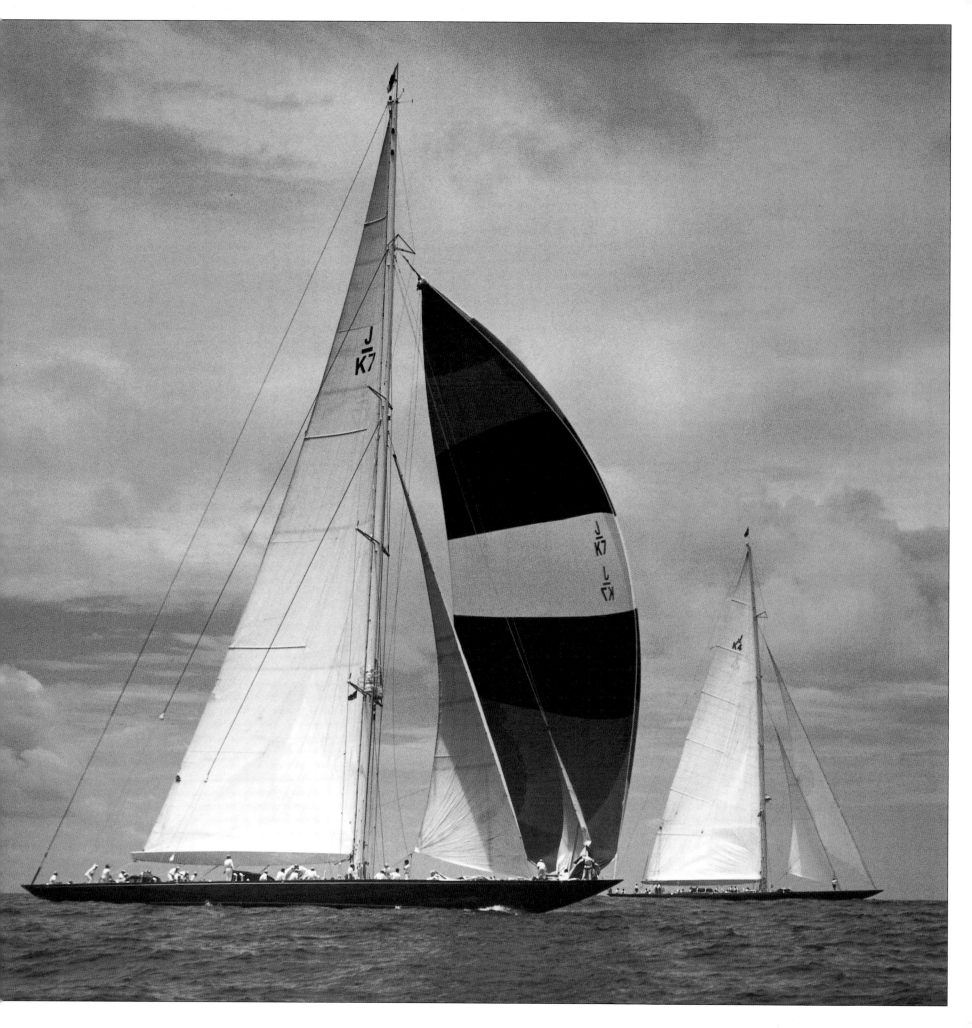

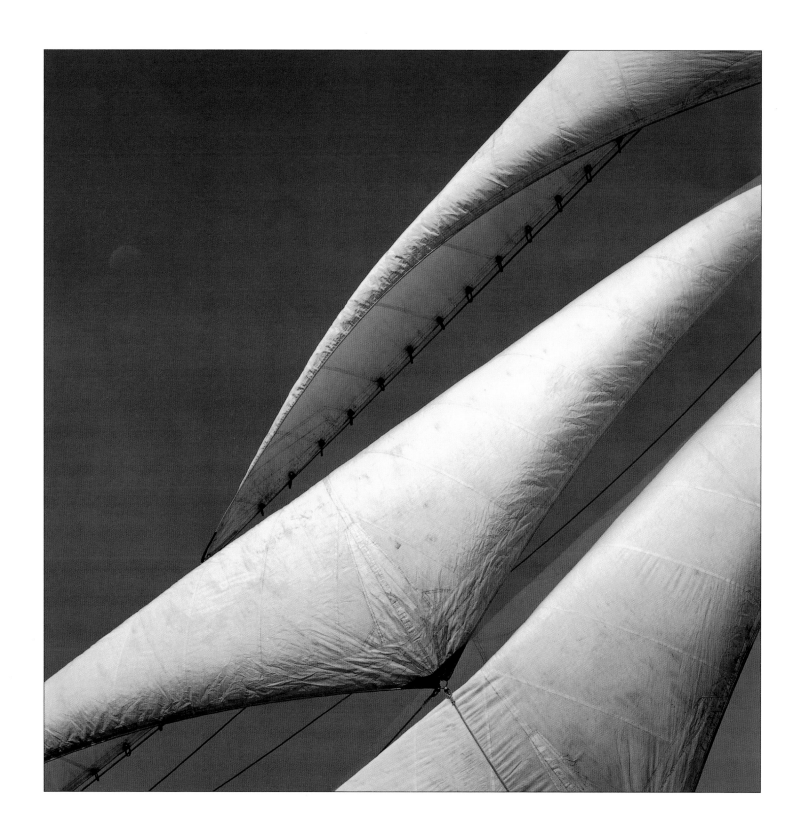

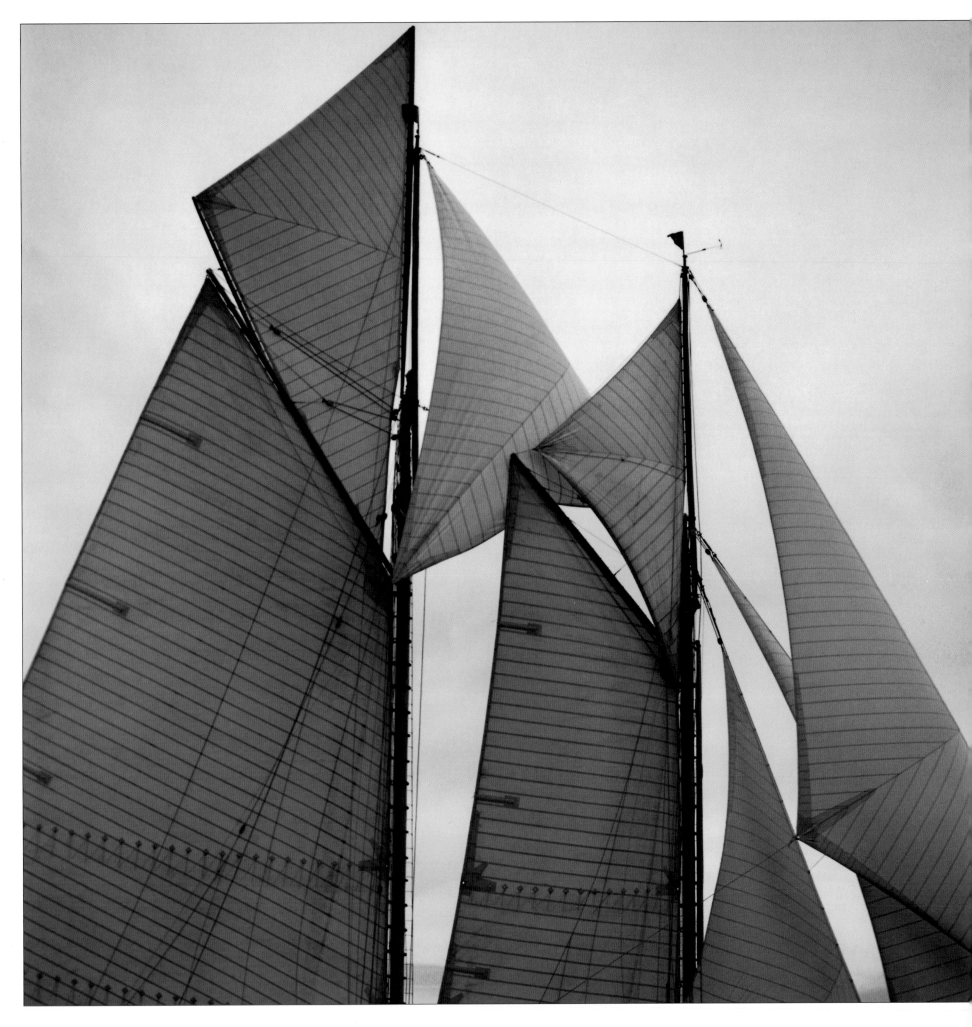

HIGH ON THE *masts*, WITH PALE AND LURID RAYS

AMIDST THE GLOOM PORTENTOUS METEORS *blaze*.

—WILLIAM FALCONER (1732–1769)
SCOTTISH POET

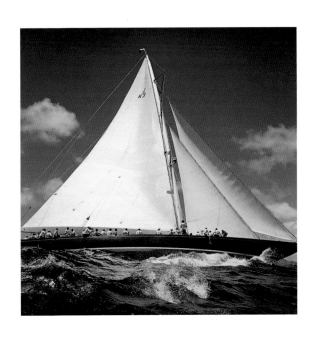

THE SEA AND SAILING

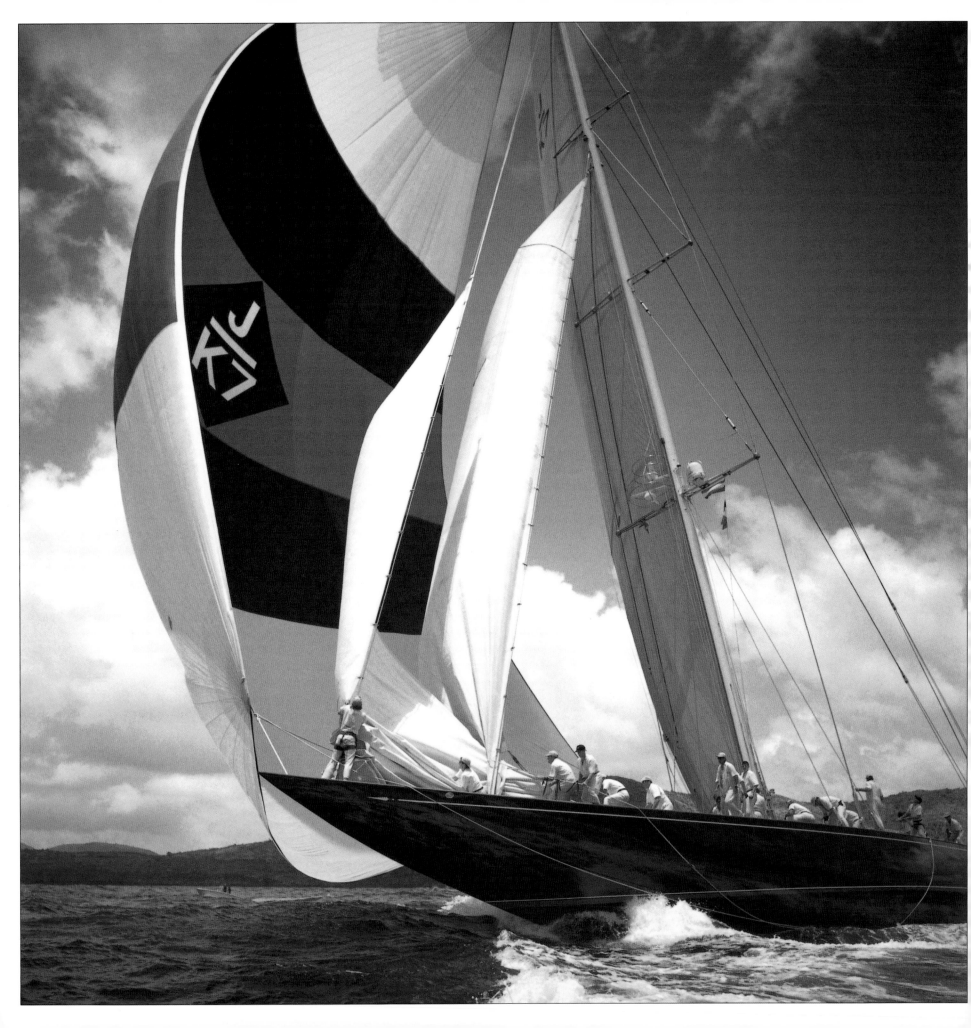

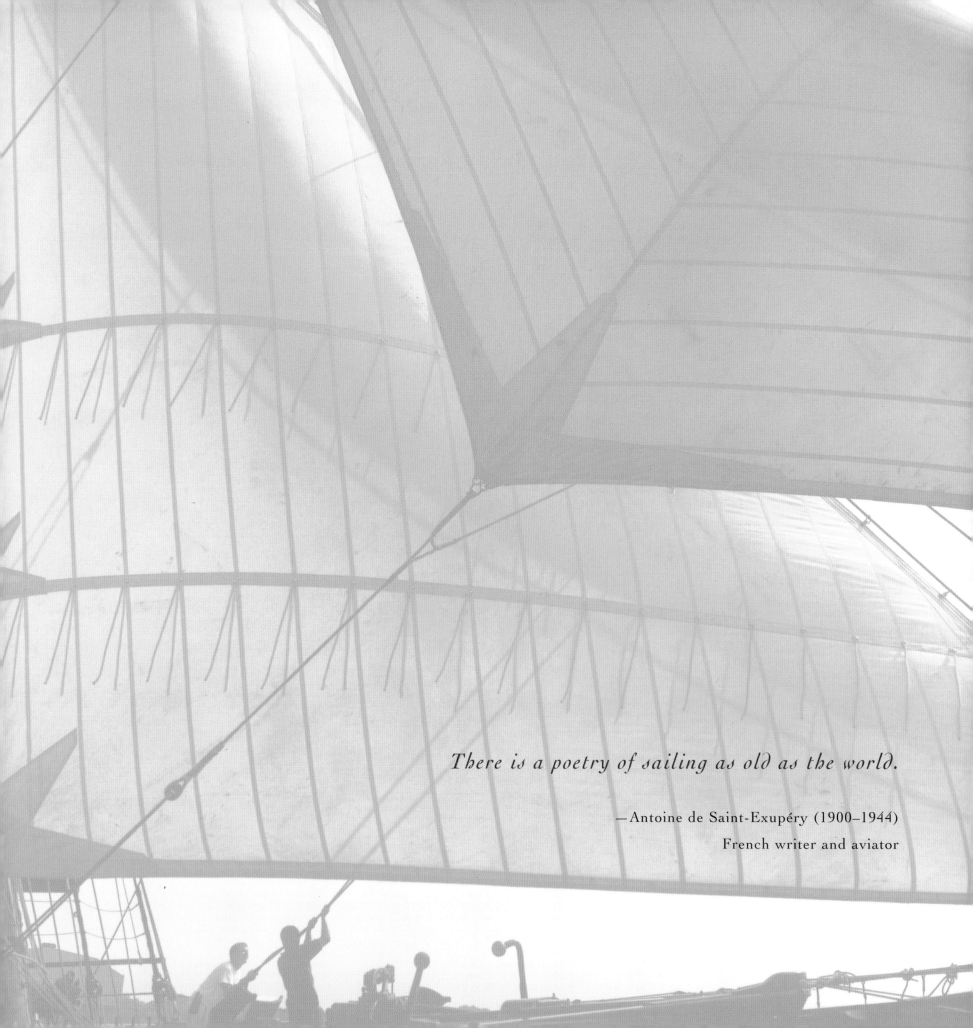

There is a poetry of sailing as old as the world.

—Antoine de Saint-Exupéry (1900–1944)

French writer and aviator

I MUST DOWN TO THE SEAS AGAIN,

TO THE LONELY SEA AND THE SKY,

ALL I ASK IS A TALL SHIP AND A STAR TO STEER HER BY . . .

—From "Sea Fever"
John Masefield (1878–1967)
British poet

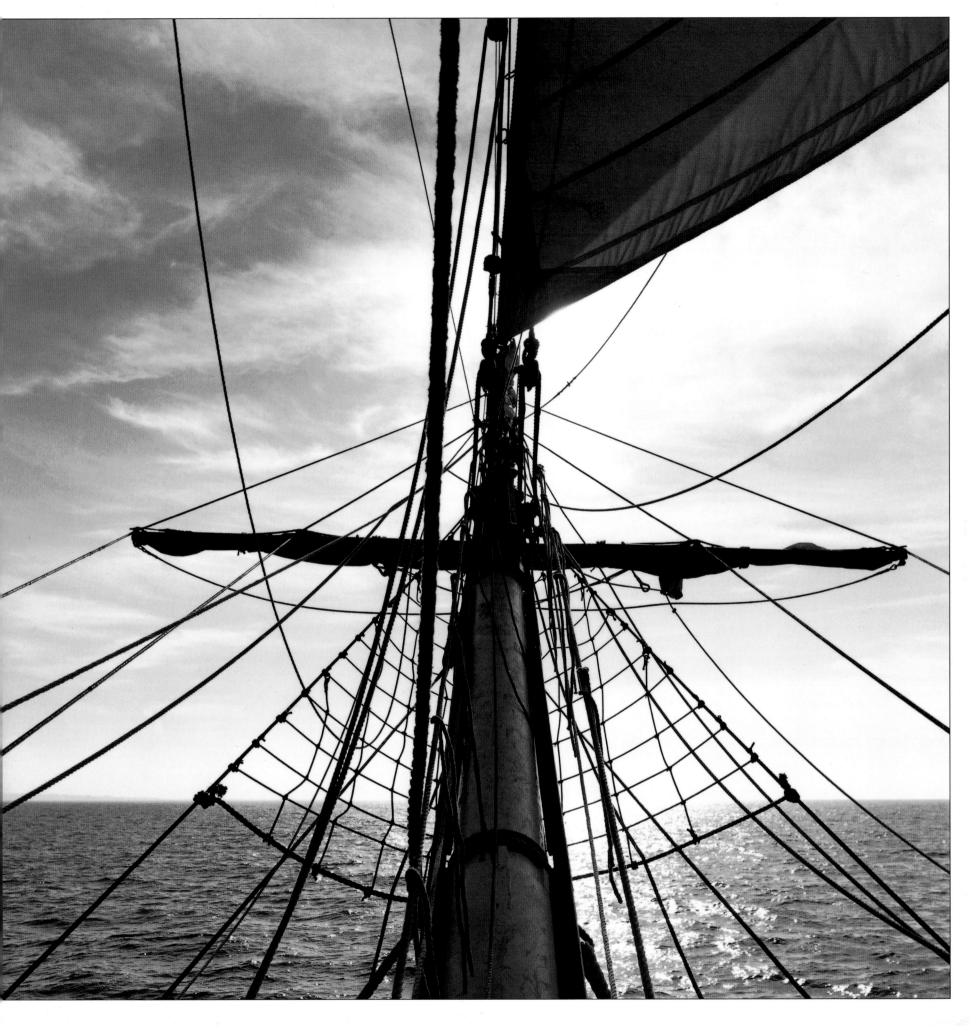

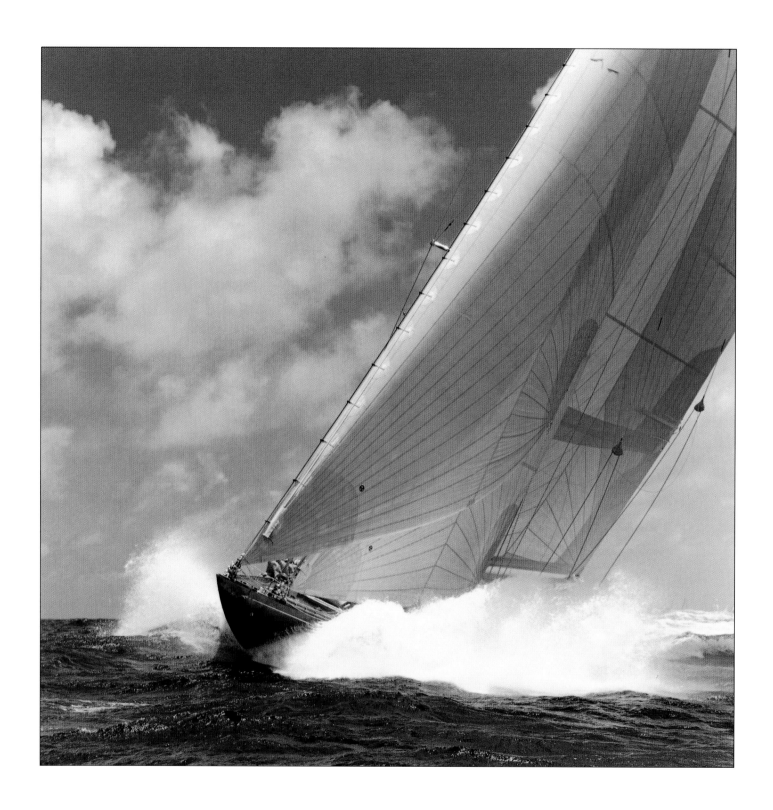

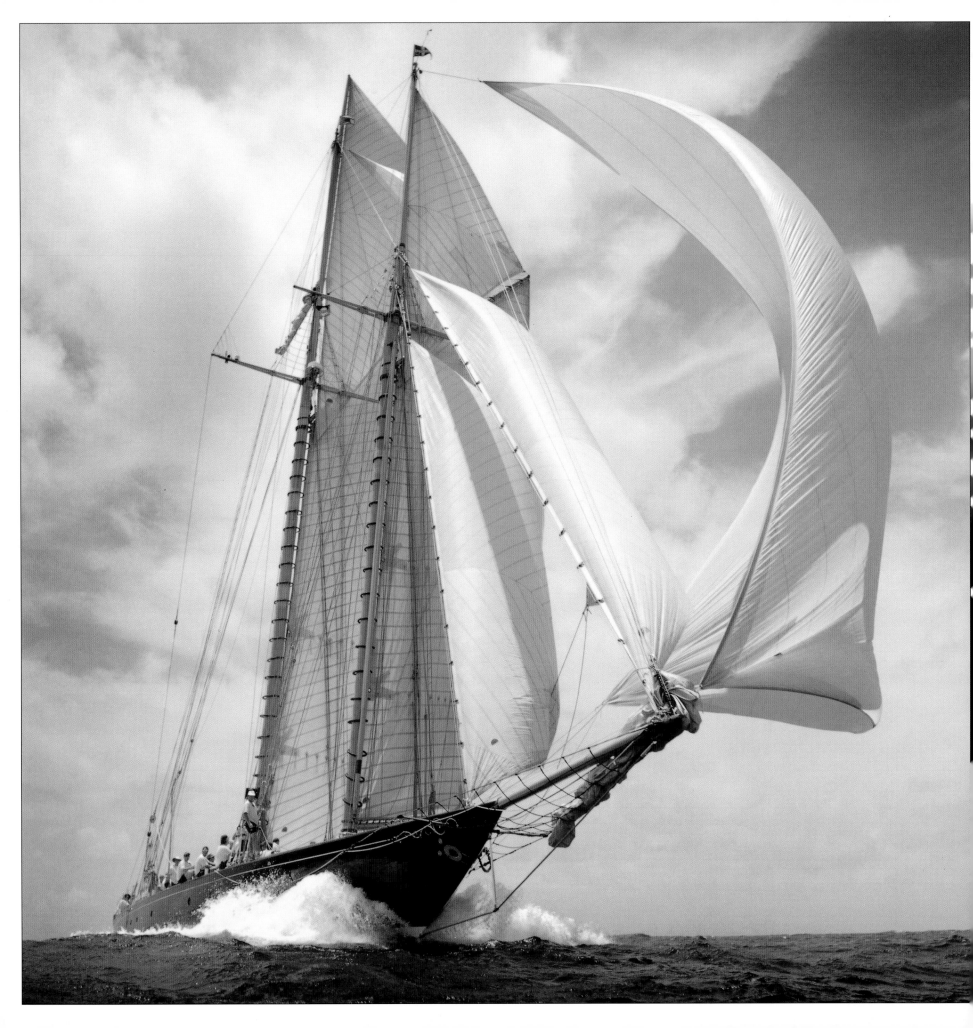

I HAVE SEEN OLD SHIPS

SAIL LIKE *swans* ASLEEP . . .

—From "The Old Ships"

James Elroy Flecker (1884–1915)

British poet

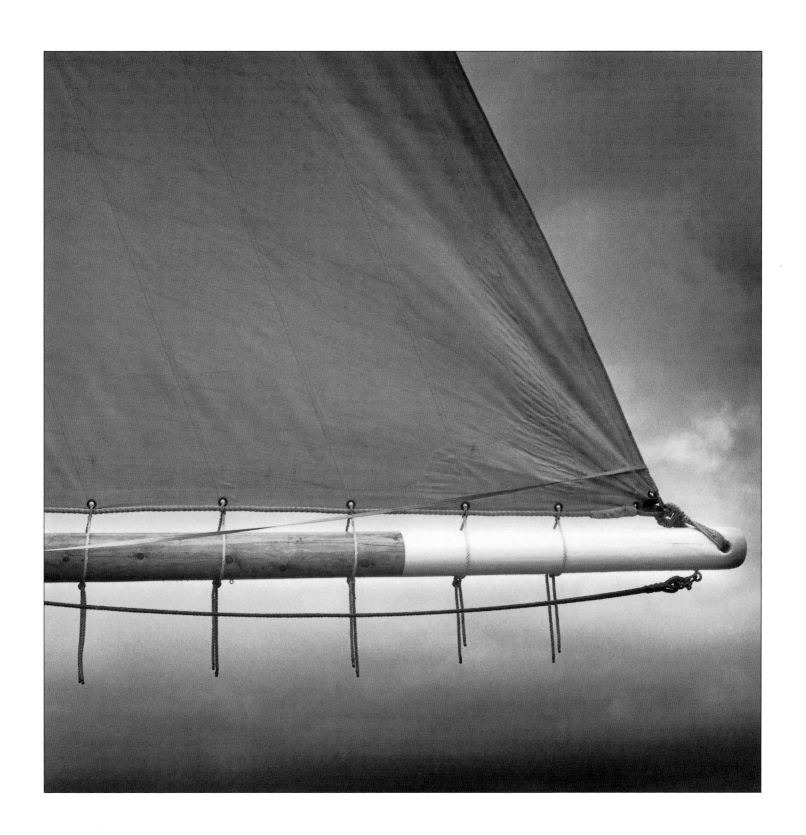

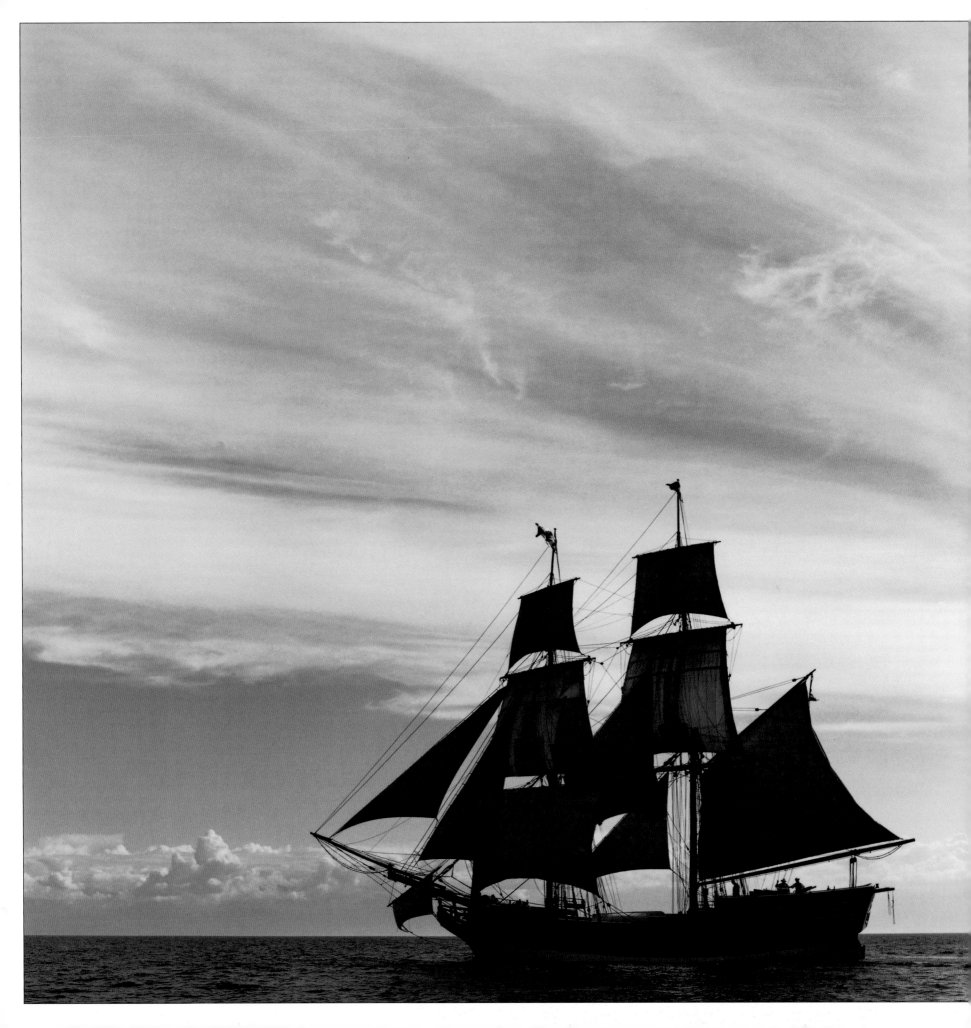

*The windjammers . . . tall ships around the world
whose very presence bespeaks man's centuries-old
struggle against the inexorabilities of the sea.*

—Deirdre Carmody
(20th Century)
American journalist

TWENTY YEARS FROM NOW, YOU WILL BE MORE DISAPPOINTED BY THE THINGS YOU DIDN'T DO THAN BY THE ONES YOU DID DO. SO THROW OFF THE BOWLINES. SAIL AWAY FROM THE SAFE HARBOR. CATCH THE TRADE WINDS IN YOUR SAILS. EXPLORE. DREAM. DISCOVER.

—MARK TWAIN (1835–1910)
AMERICAN WRITER AND HUMORIST

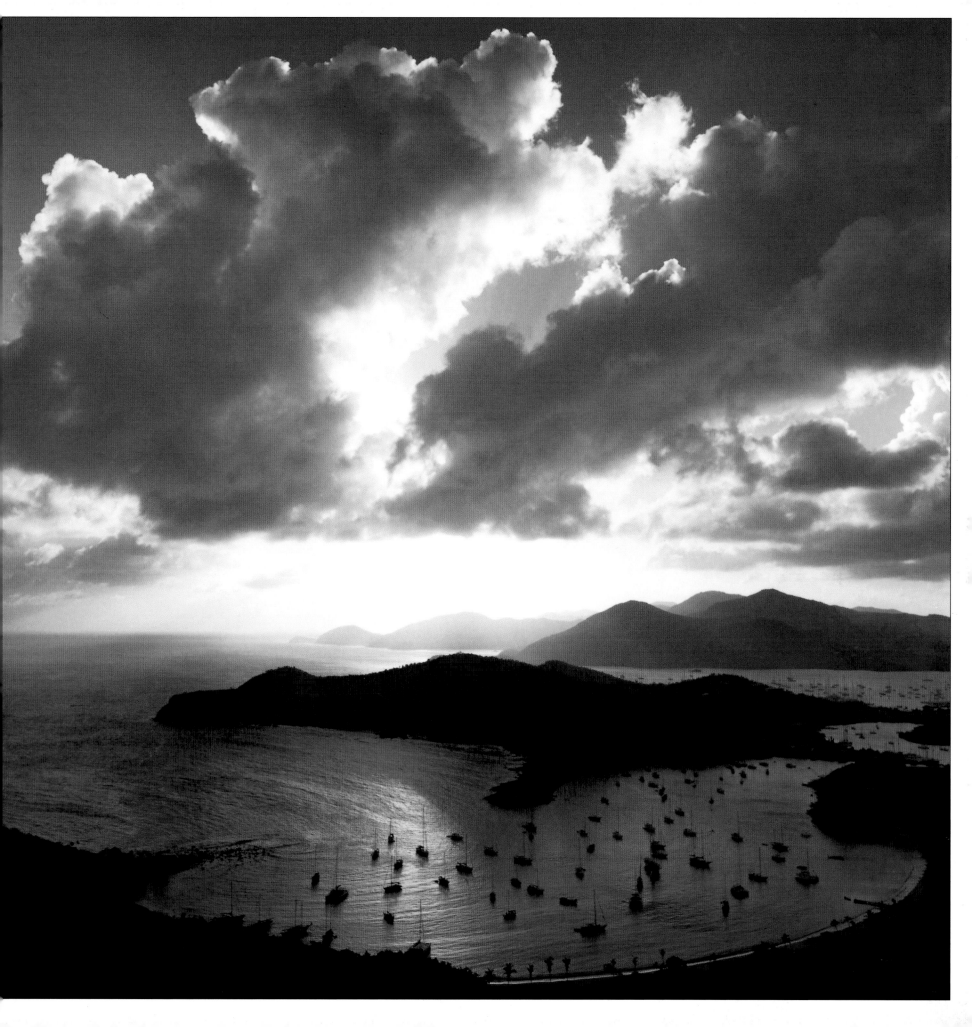

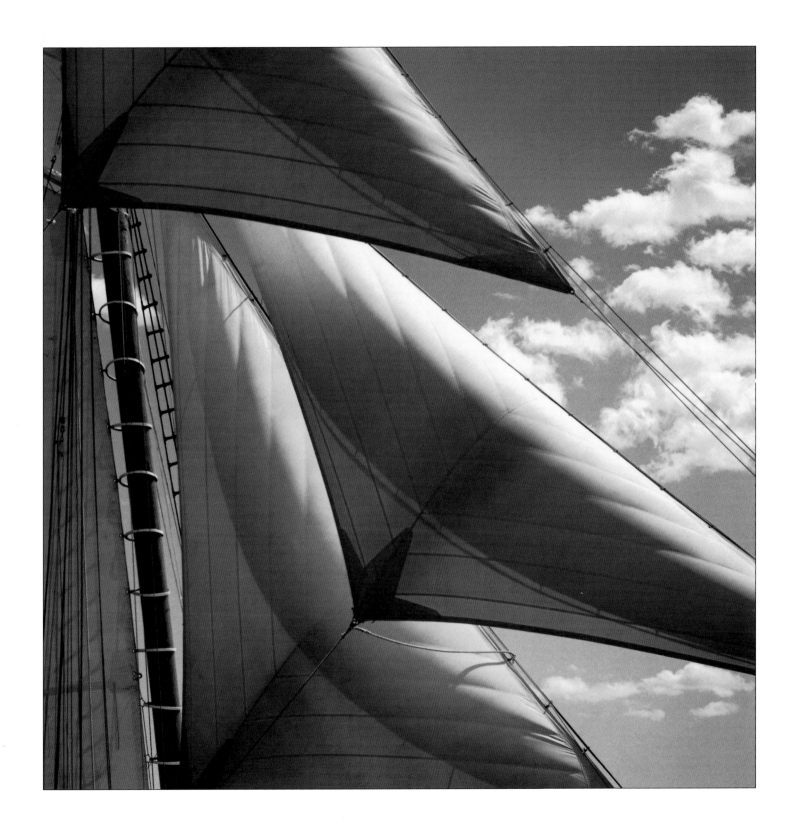

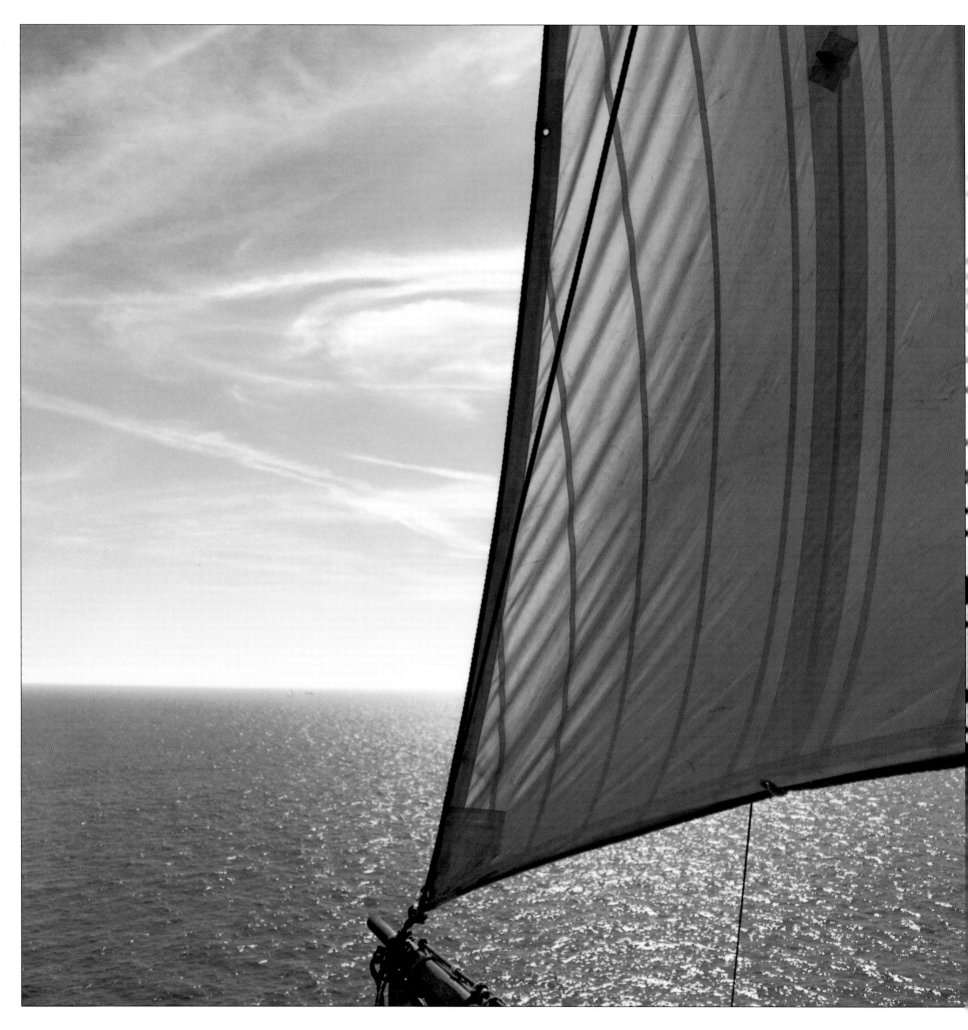

INDEED, THE CRUISING OF A BOAT

HERE AND THERE IS VERY MUCH

soul

WHAT HAPPENS TO THE SOUL OF

MAN IN A LARGER WAY. WE SET OUT

FOR PLACES WHICH WE DO NOT

REACH, OR REACH TOO LATE; AND

ON THE WAY, THERE BEFALL US ALL

MANNER OF THINGS WHICH WE

COULD NEVER HAVE AWAITED.

—Hilaire Belloc (1870–1953)
French-born British poet,
historian and essayist

Never a ship sails out of bay,

but carries my heart as a stowaway.

ROSELLE MERCIER MONTGOMERY
(1874–1933)
AMERICAN WRITER

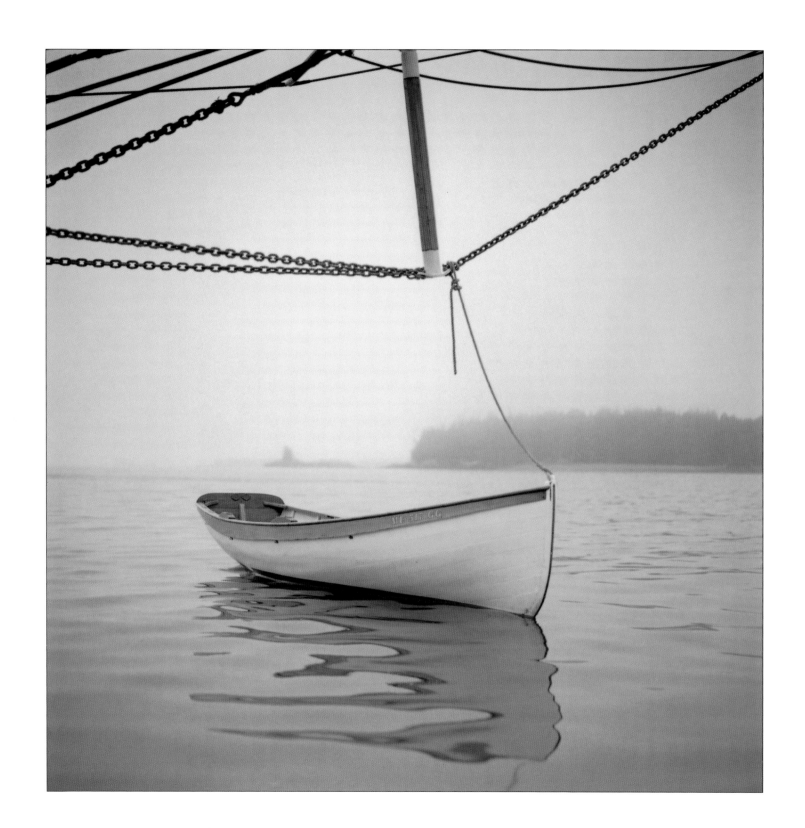

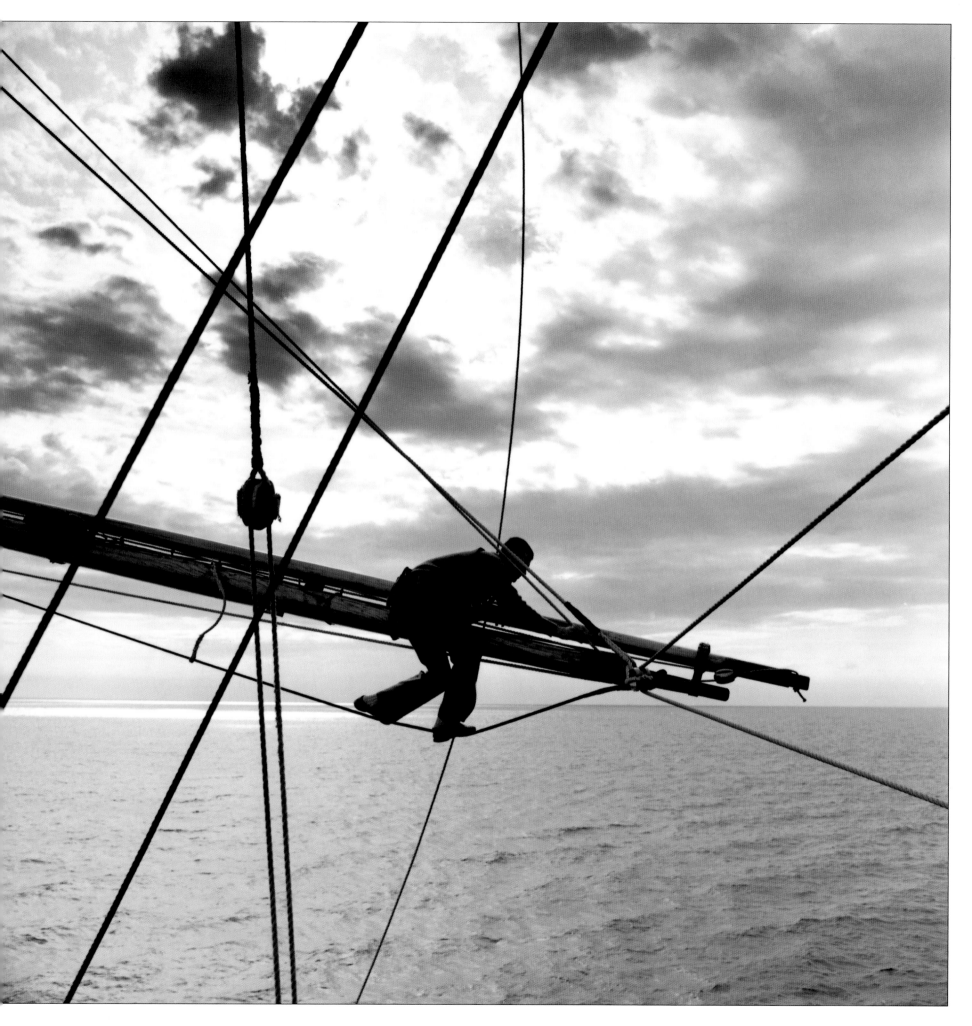

FOR ALL AT LAST RETURN TO THE *sea* —TO OCEANUS,

THE OCEAN *river*, LIKE THE EVERFLOWING RIVER

OF TIME, THE BEGINNING AND THE *end*.

—RACHEL CARSON (1907–1964)

AMERICAN BIOLOGIST AND WRITER

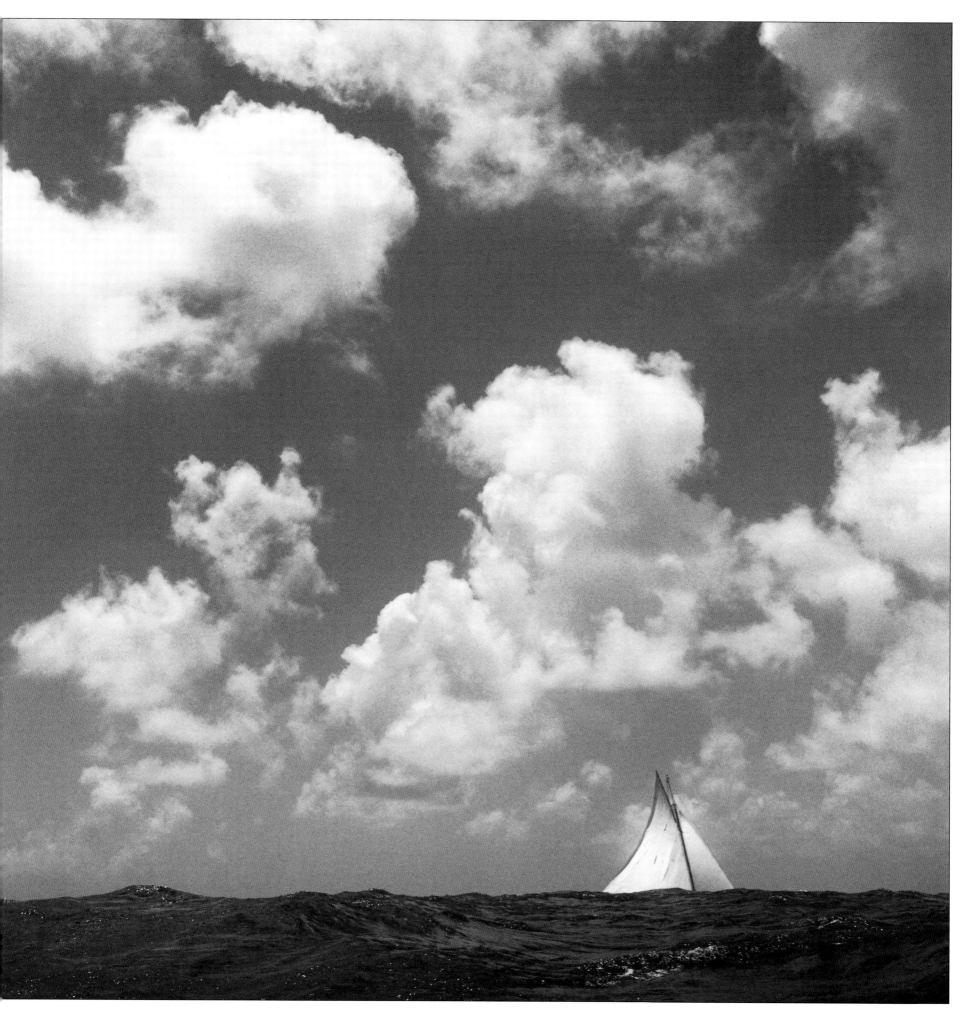

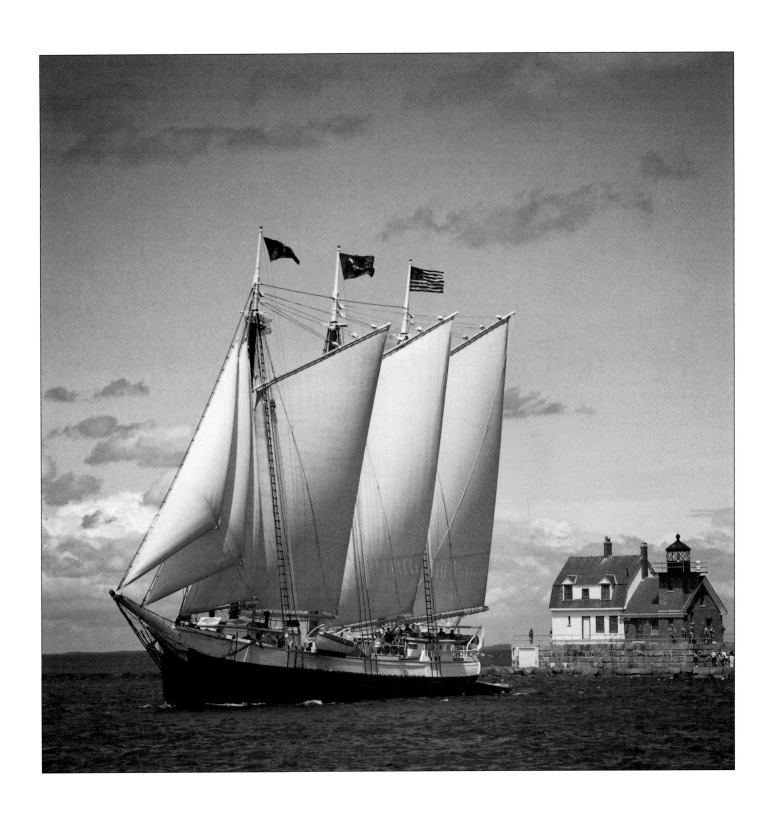

And men go forth, and admire lofty mountains and broad seas, and roaming torrents, and the course of the stars, and forget their own selves in doing so.

—Petrarch (1304–1374)
Italian Humanist and poet

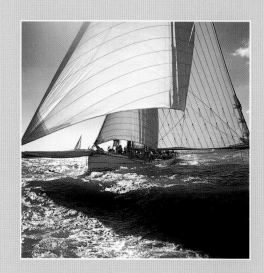

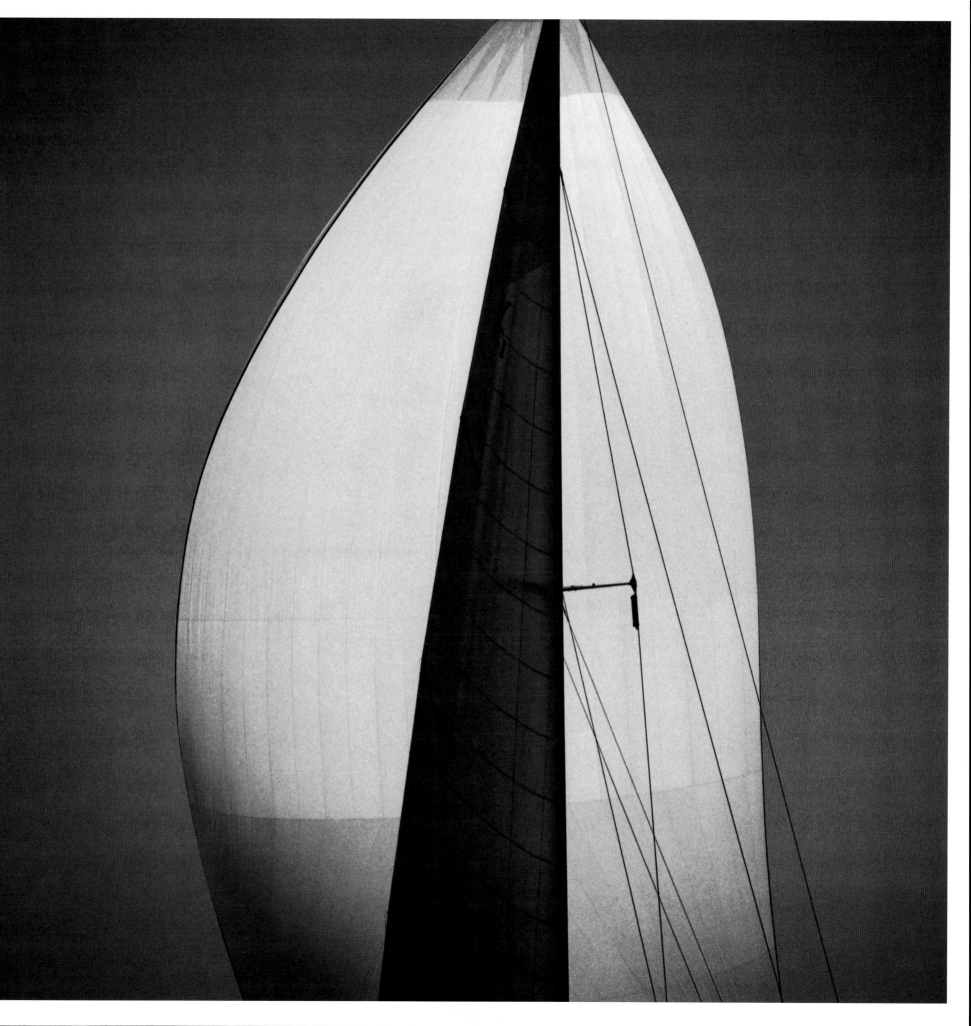

WE COULD CUT A PATH JUST
THIRTEEN FEET AND NINE INCHES
ACROSS THIS OCEAN, LIKE A
METEOR WANDERING THROUGH
THE SOLAR SYSTEM.

—Ray Kauffman (b. 1905)
American yacht designer

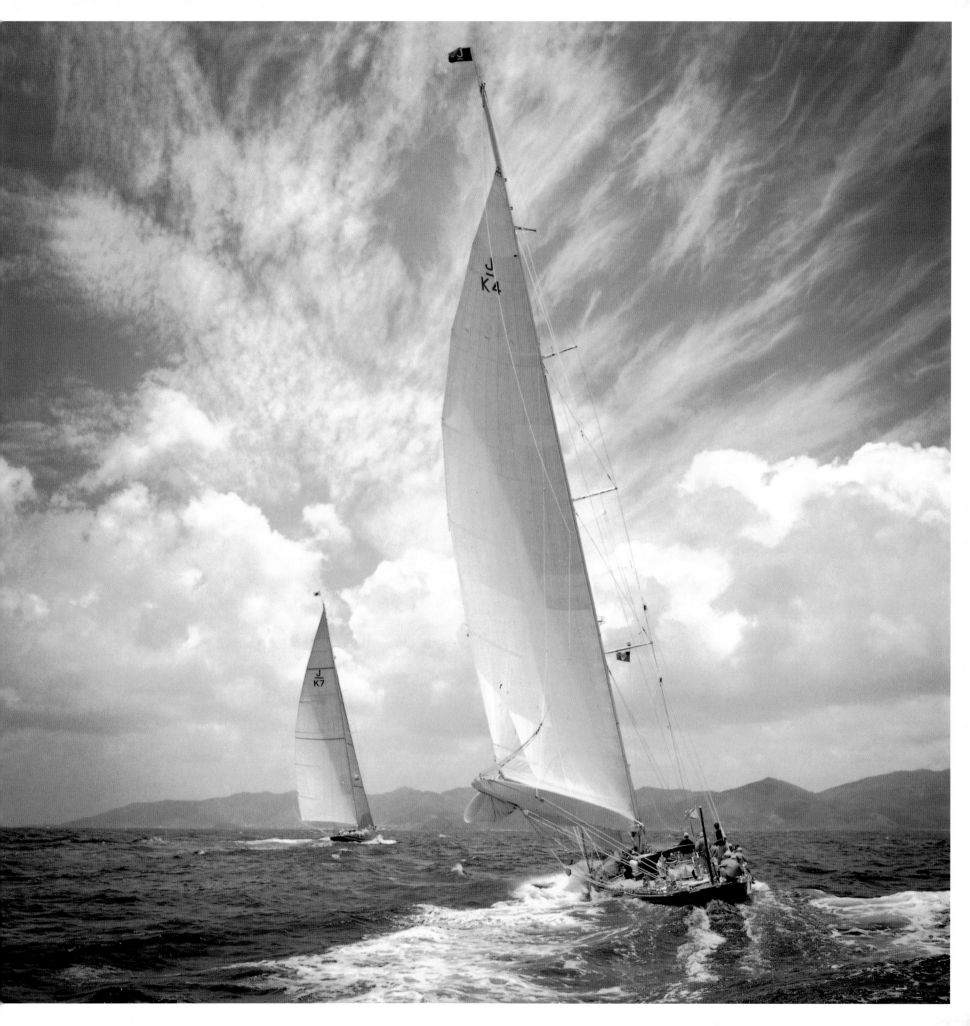

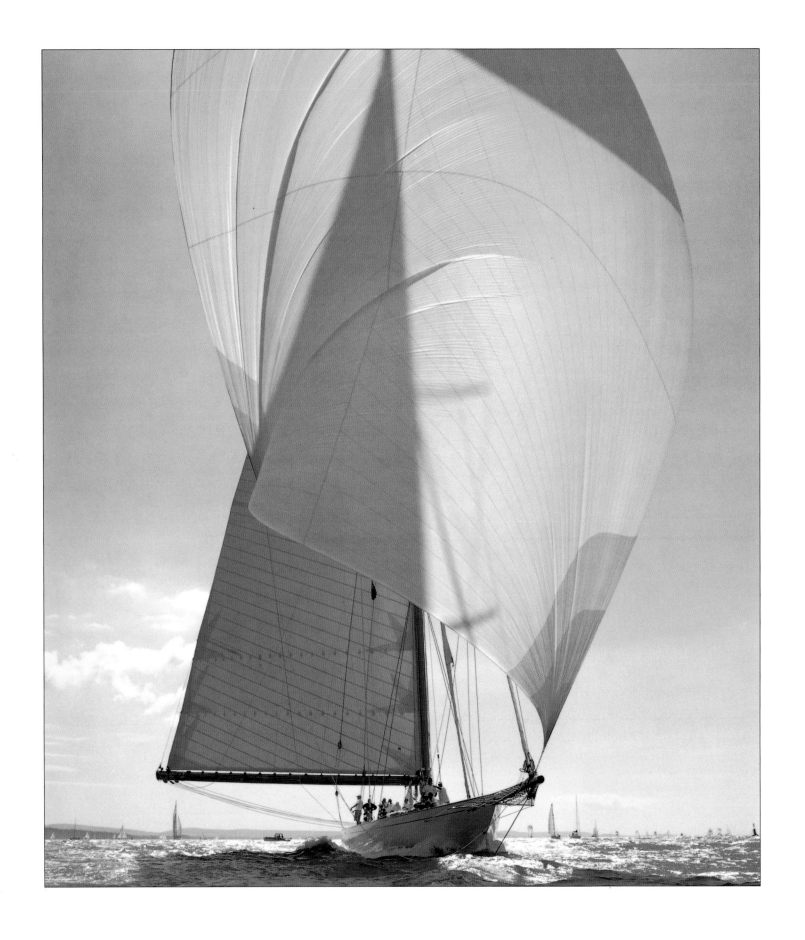

THUS I STEER *sail* MY BARK, AND SAIL

ON EVEN KEEL,

WITH GENTLE GALE.

—From "The Spleen"
Matthew Green (1696–1737)
British poet

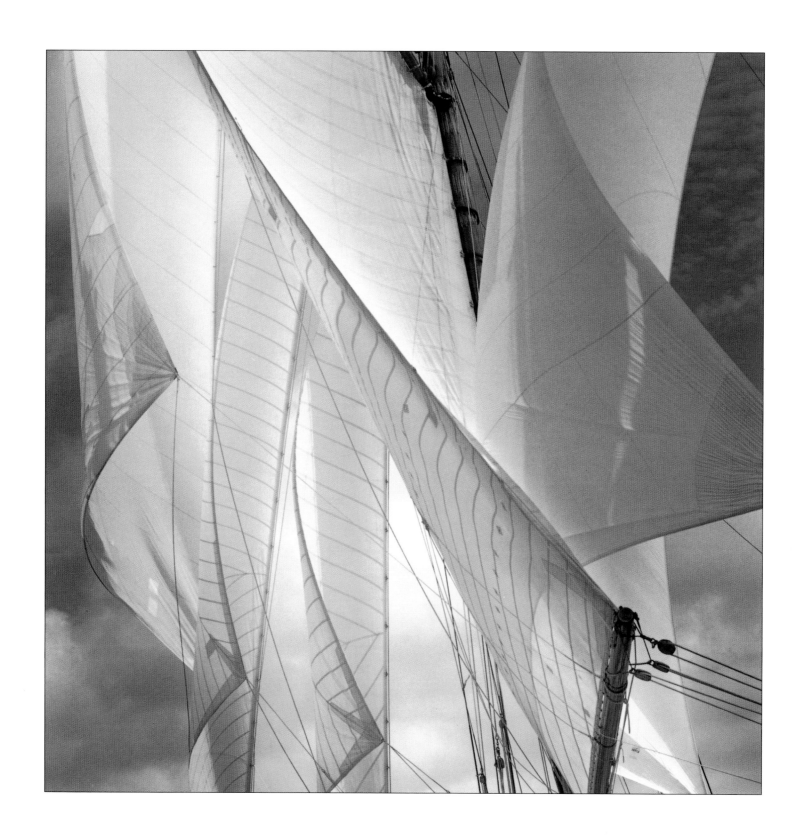

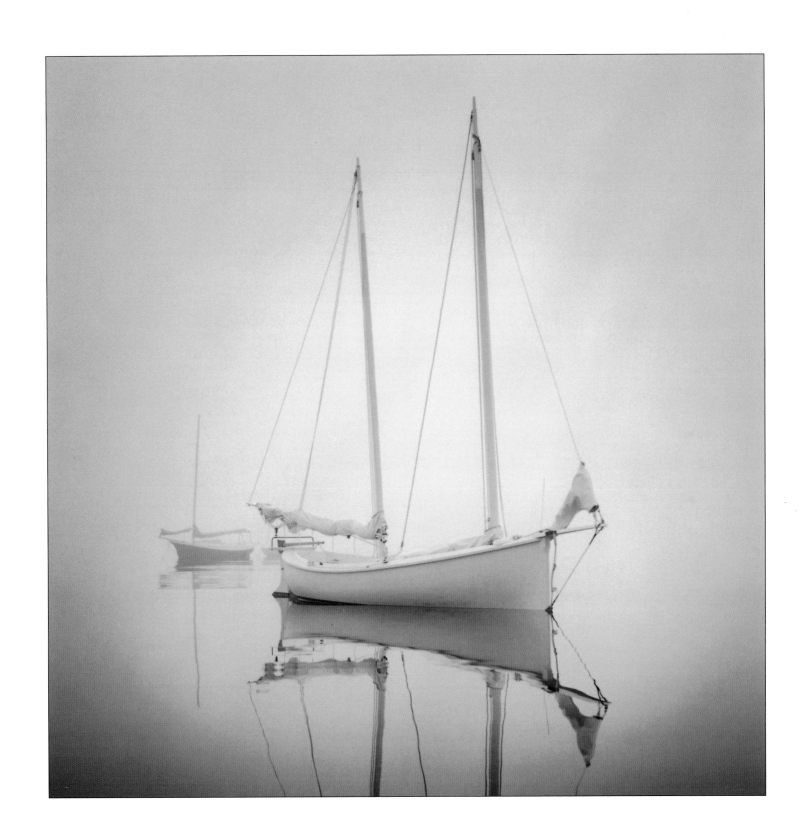

THE RESTIVE WATERS, THE COLD WET BREATH OF THE

FOG, ARE OF A WORLD IN WHICH MAN IS AN UNEASY

TRESPASSER; HE PUNCTUATES THE NIGHT WITH THE

COMPLAINING GROAN AND GRUNT OF A FOGHORN,

SENSING THE POWER AND MENACE OF THE SEA.

—Rachel Carson (1907–1964)
American biologist and writer

WE'VE ALL TRIED TO DESCRIBE WHAT IT IS THAT COMPELS US TO SAIL, BUT IT SEEMS INEFFABLE. SAILING IS NEVER THE SAME BUT ALWAYS SUBLIME. FOR ME, IT'S AN ENORMOUS RANGE OF EXTREMES, ALL OF THEM PROVIDING A SENSE OF BEING FULLY ALIVE. I LOVE THE DAWN WATCH OFFSHORE WHEN DEW FALLS ON THE OCEAN AND FILLS THE AIR WITH THE SMELL OF FRESH WATER. I LOVE THOSE MOMENTS IN THE MIDST OF ALL HELL BREAKING LOOSE WHEN I REALIZE I AM UNAFRAID AND COMPETENT TO KEEP THE BOAT SAFE. I LOVE HEADING OFF FOR SOMEWHERE FAR AWAY WITH A BOATLOAD OF GOOD FRIENDS. I LOVE THOSE WILD NIGHTS IN THE TRADE WINDS WITH HUGE SEAS AND MOONLIGHT WHEN THE BOAT ROARS AND THRASHES AND FLIES ALONG FLINGING SPRAY. I LOVE BEING STUCK OUT IN THE WEATHER, GOOD AND BAD, AND SEEING ENDLESS CHANGES IN SEA AND SKY. I LOVE THE WISTFUL FEELING OF A CHILLY SAIL IN A SMALL BOAT IN LATE FALL, WHEN I KNOW I SHOULD ALREADY HAVE PUT HER IN THE SHED.

—Elizabeth Meyer (20th Century)
American sailor and founder of International
Yacht Restoration School

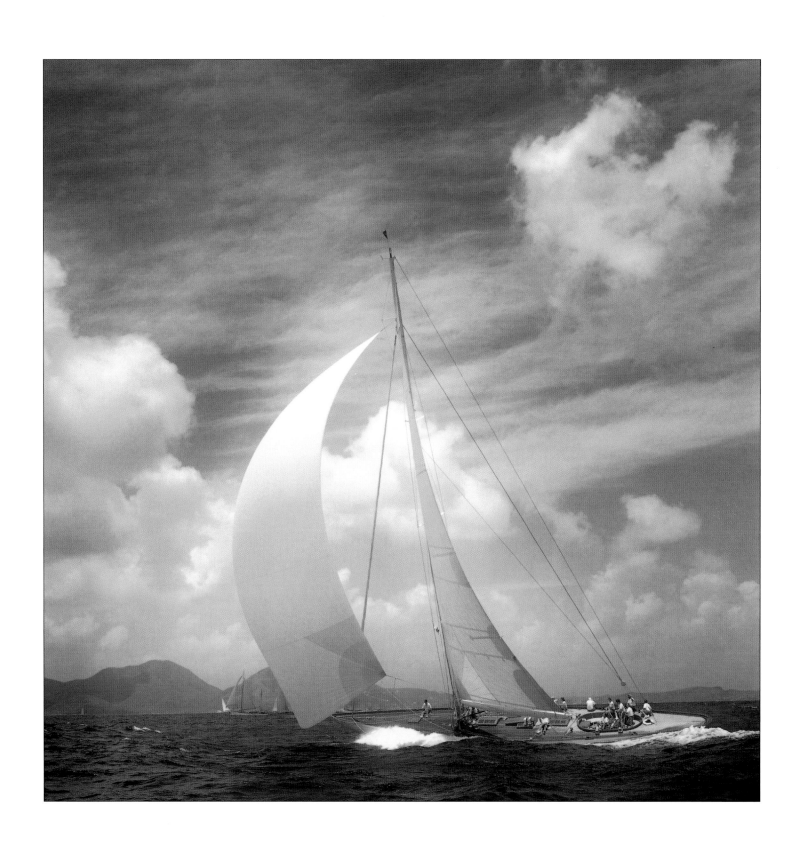

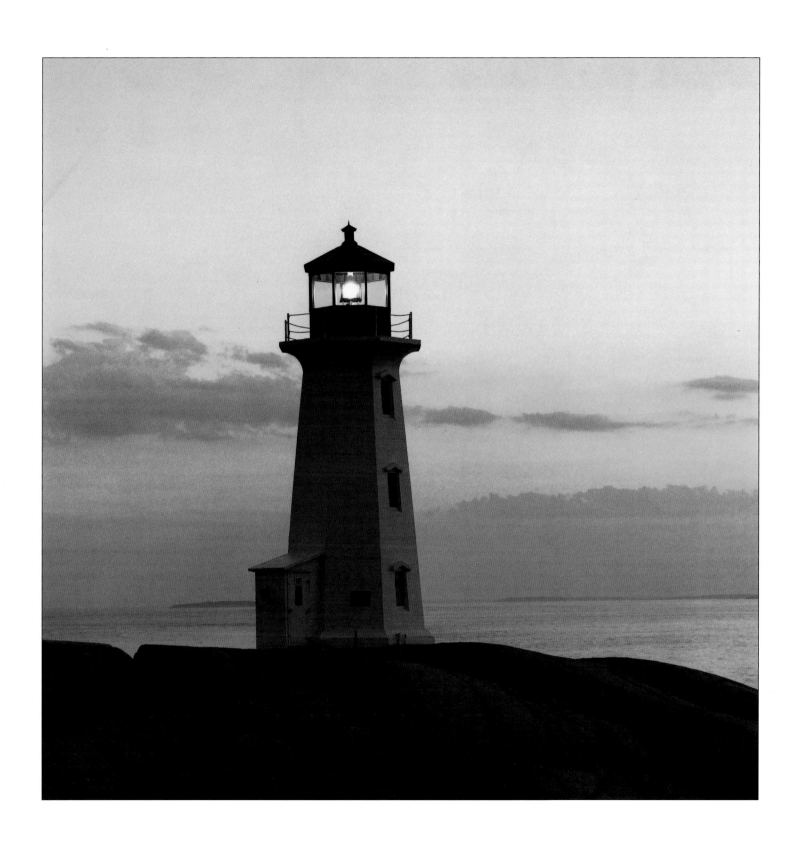

T here's no opium so sweet as the unguarded sunny sleep

on the deck of a boat when it's after lunch in summer

and you don't know when you're going to arrive nor

what port you will land at, when you've forgotten

east and west and your name and address . . .

JOHN DOS PASSOS (1896–1970)
AMERICAN WRITER

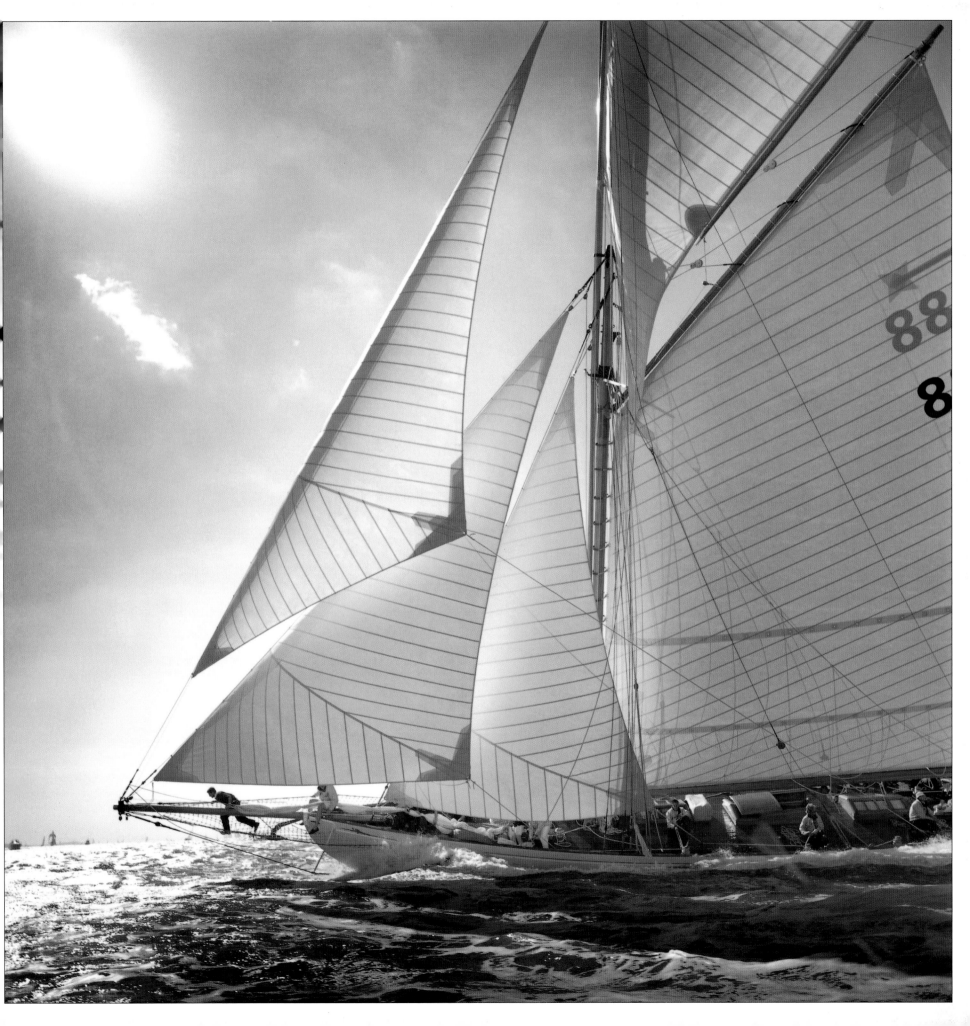

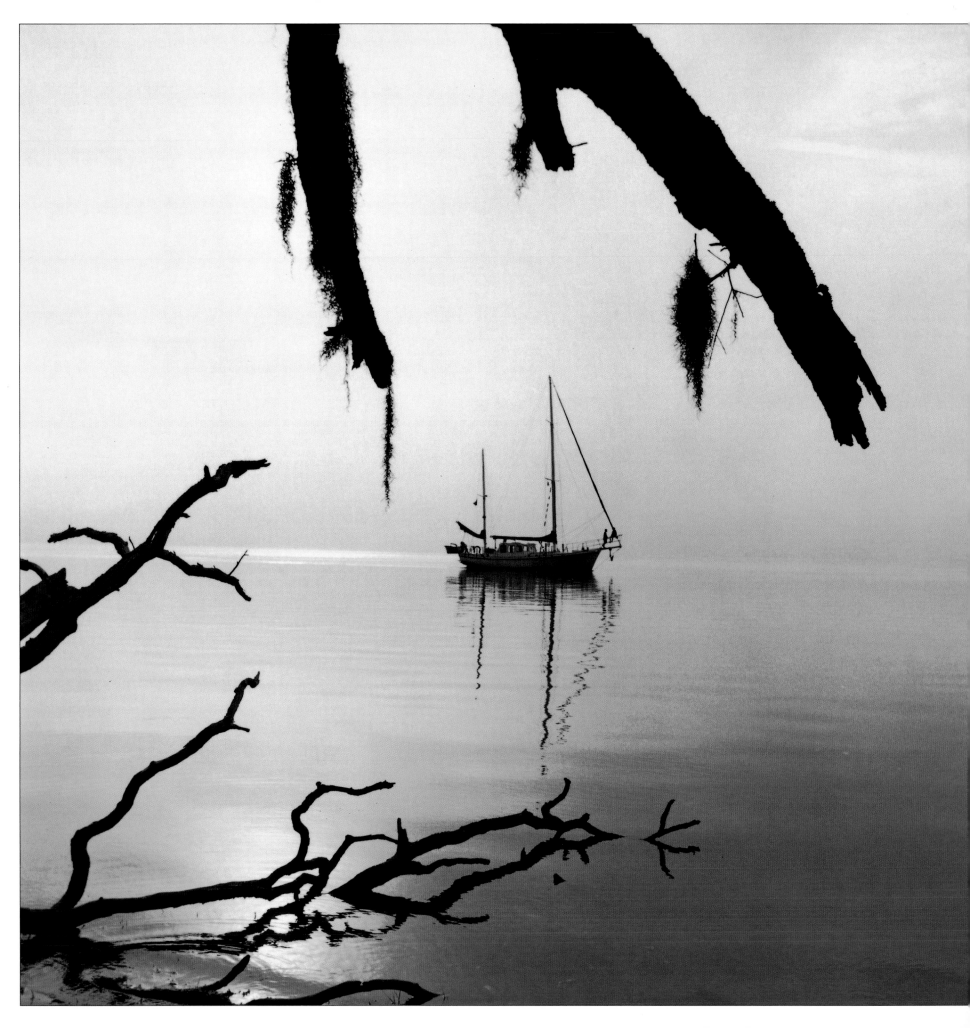

In the artificial world of his cities and towns, man often forgets the true nature of his planet. The sense of all these things comes to him most clearly in the course of a long ocean voyage, when he watches day after day the receding rim of the horizon, ridged and furrowed by waves. . . . And then, as never on land, he knows the truth that his world is a water world, a planet dominated by its covering mantle of ocean, in which the continents are but transient intrusions of land above the all-encircling sea.

—RACHEL CARSON (1907–1964)
AMERICAN BIOLOGIST AND WRITER

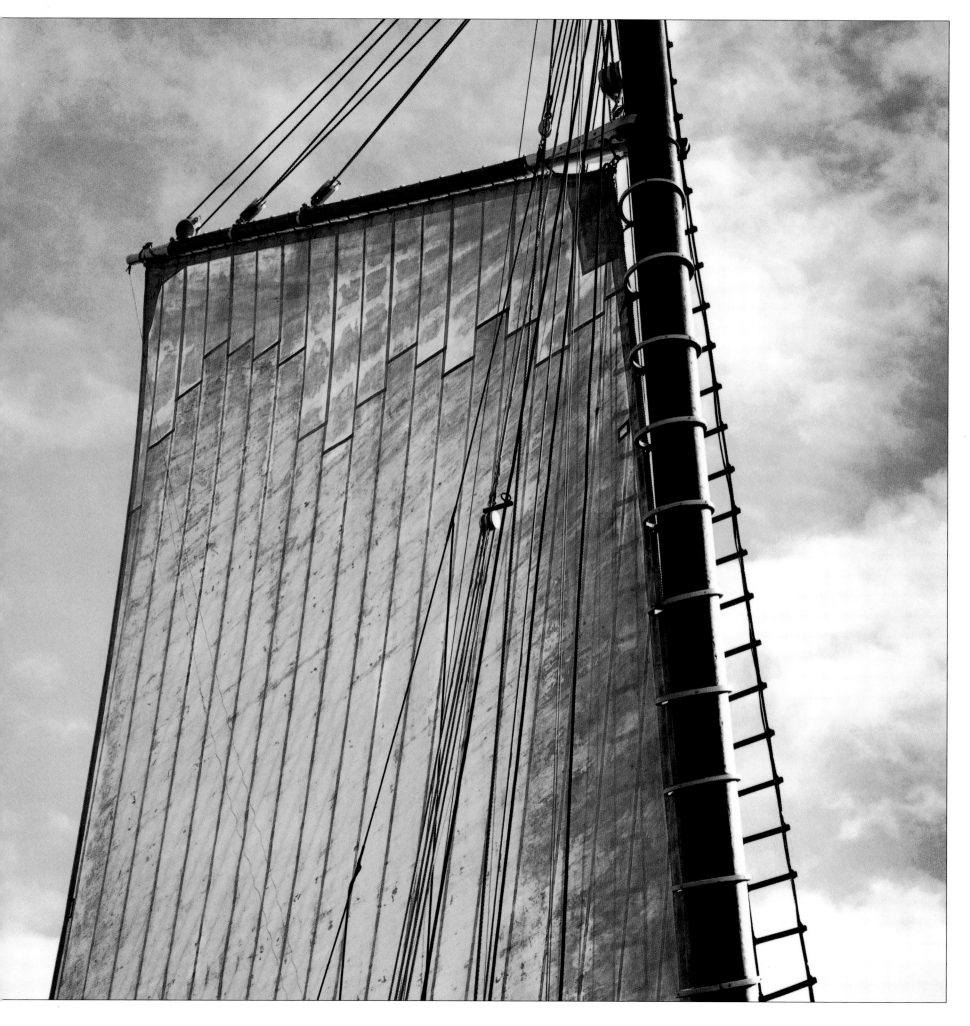

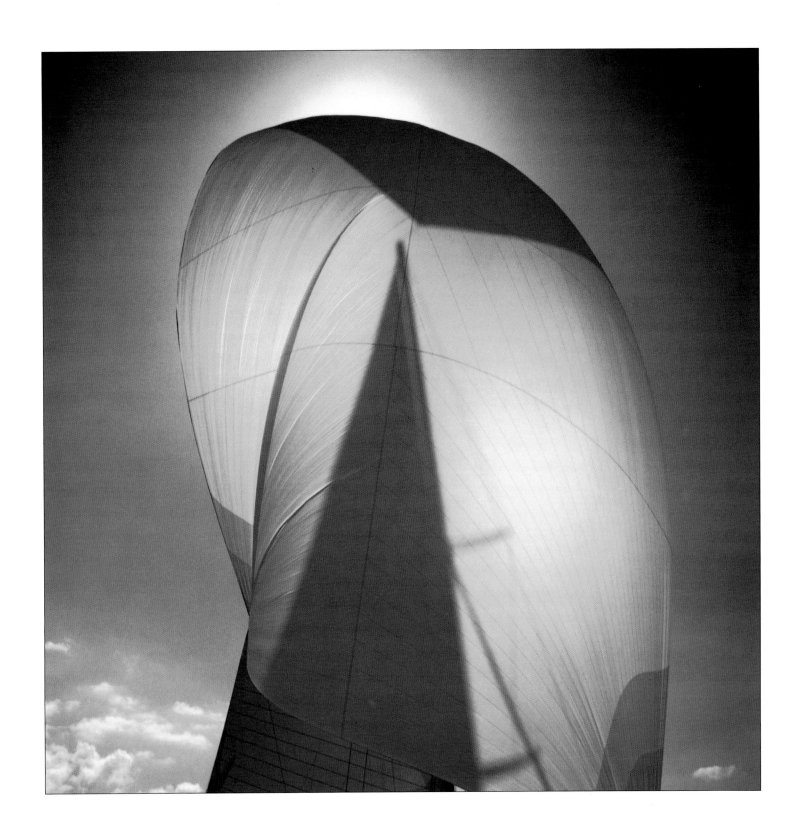

. . . OVER THE BREAKING *billows,*

WITH BELLYING SAIL, AND FOAMING BEAK, LIKE A FLYING BIRD *. . .*

—FROM *BEOWULF*

THOSE WHO LIVE BY THE SEA CAN HARDLY FORM A SINGLE

THOUGHT OF WHICH THE SEA WOULD NOT BE PART.

—HERMANN BROCH (1886–1951)

AUSTRIAN WRITER

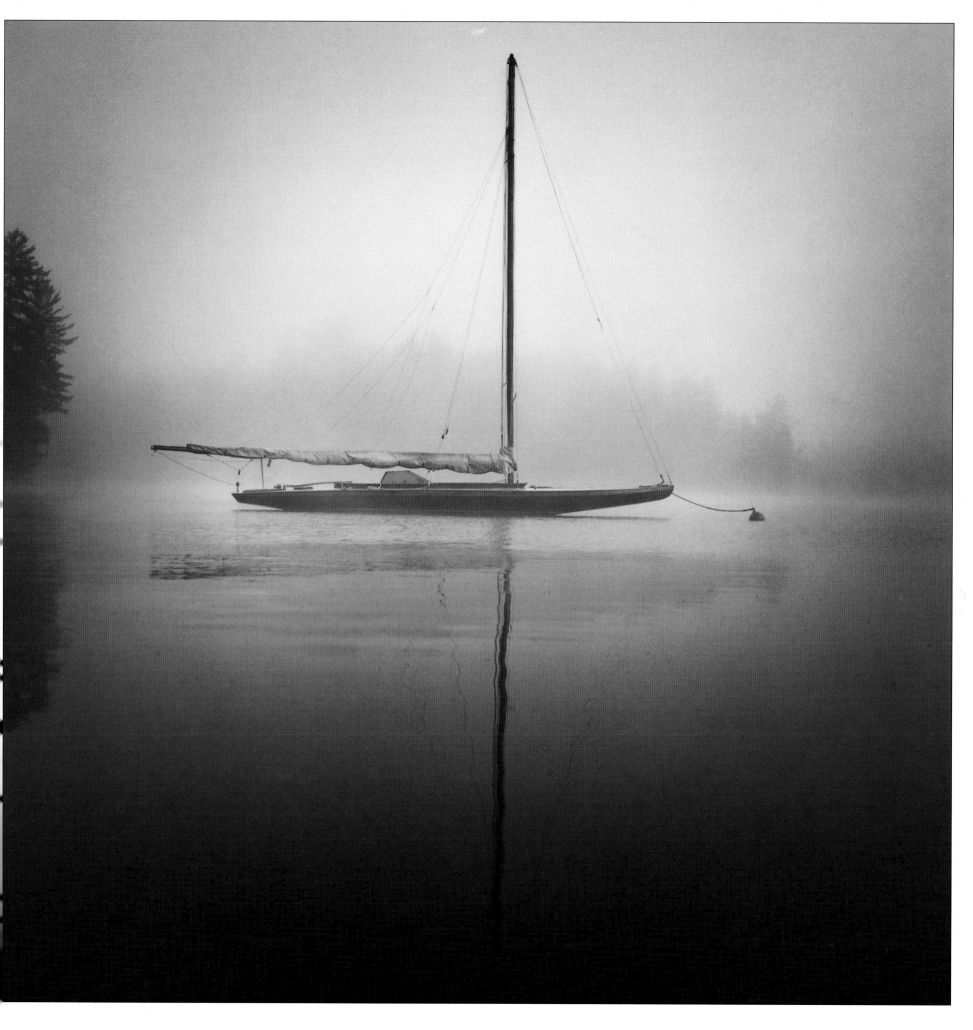

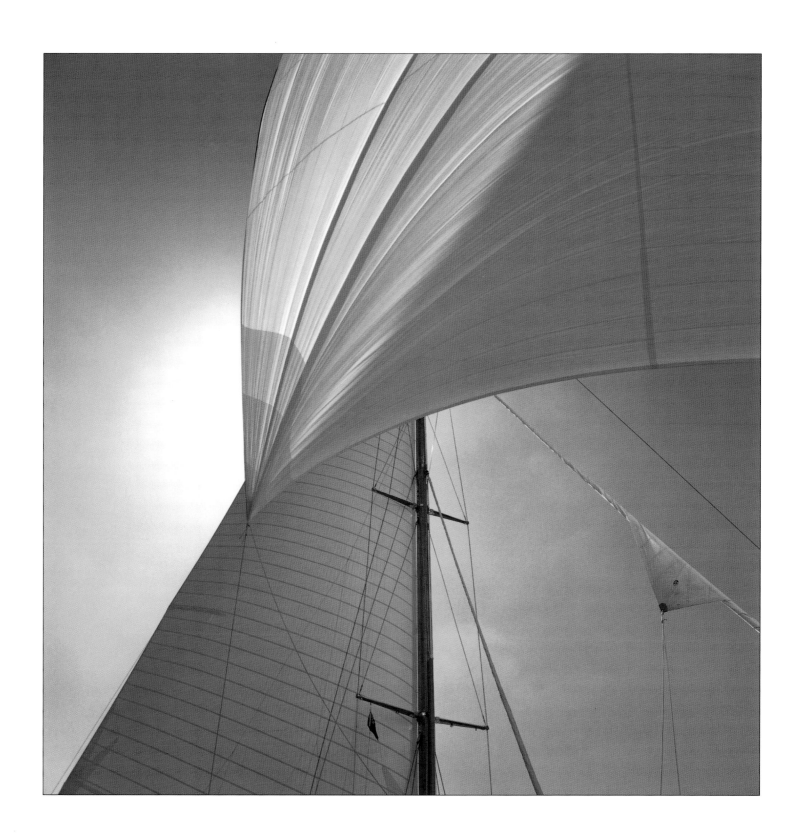

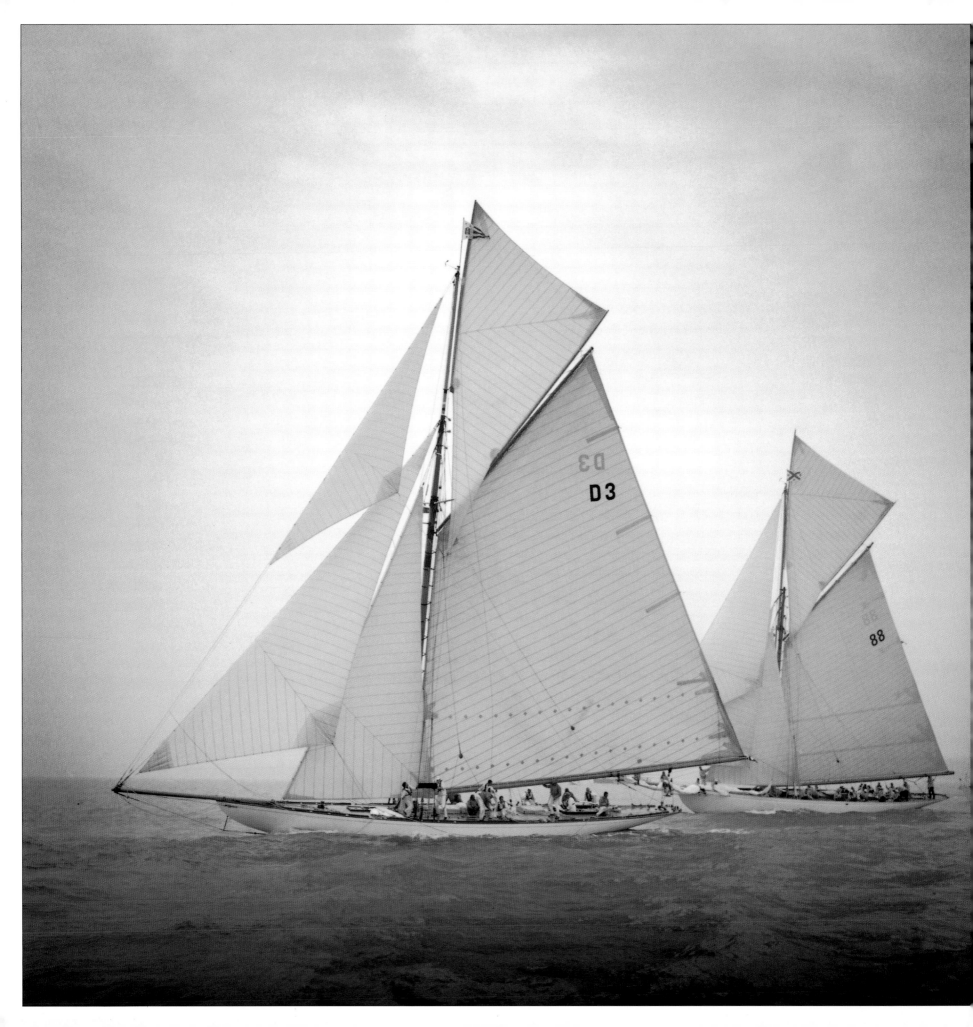

Ships that pass in the night, and speak each other in passing;

Only a signal shown and a distant voice in the darkness;

So on the ocean of life we pass and speak one another,

Only a look and a voice; then darkness again and a silence.

FROM "TALES OF A WAYSIDE INN"
HENRY WADSWORTH LONGFELLOW (1807–1882)
AMERICAN POET

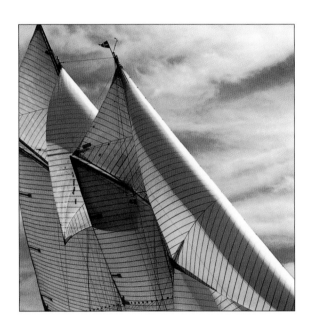

THE WIND

FOR WHAT IS THE ARRAY OF THE STRONGEST

ROPES, THE TALLEST SPARS, *breath* AND THE STOUTEST

CANVAS AGAINST THE MIGHTY BREATH OF THE

INFINITE, BUT THISTLE STALKS, COBWEBS, AND GOSSAMER?

—From *The Mirror of the Sea*
Joseph Conrad (1857–1924)
British writer

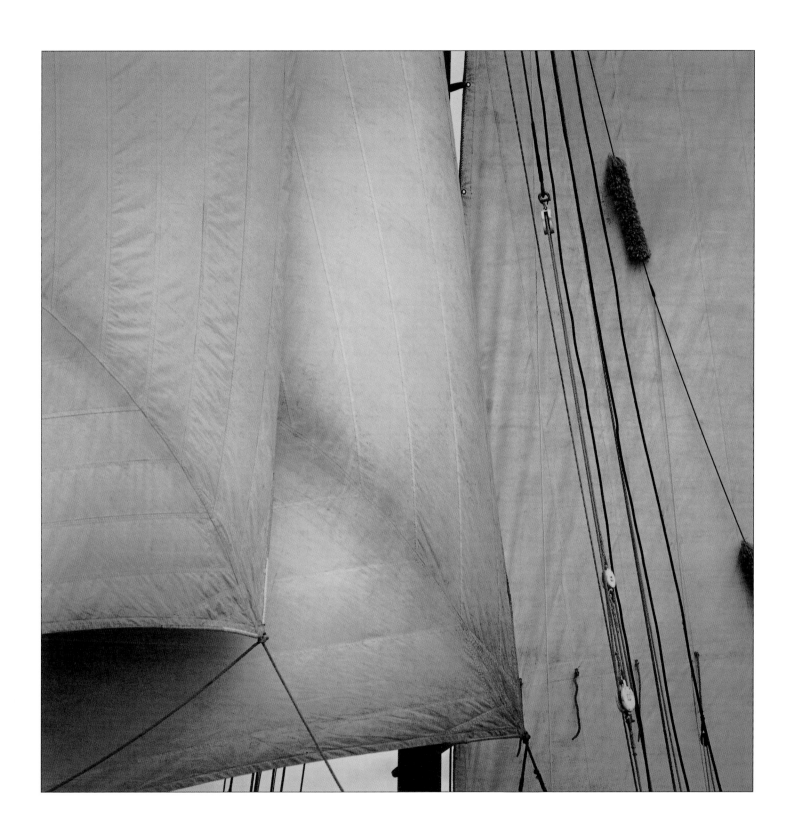

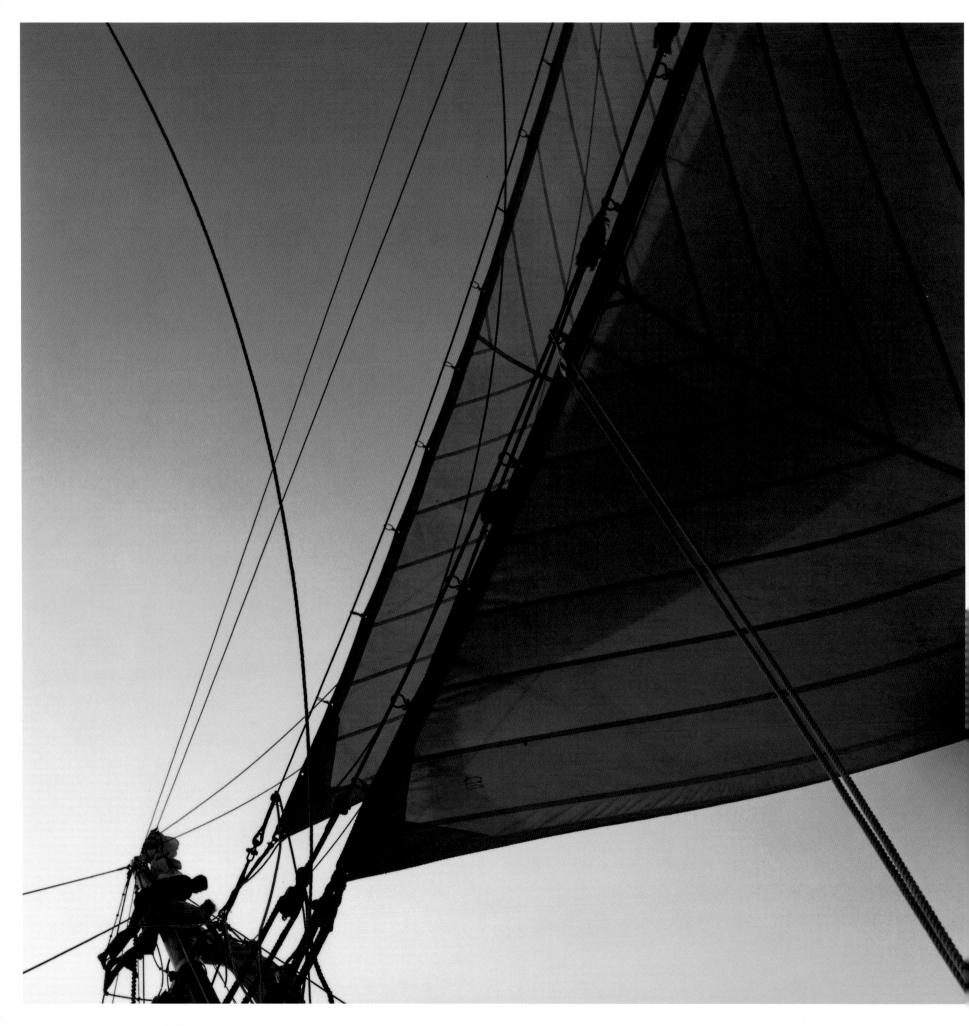

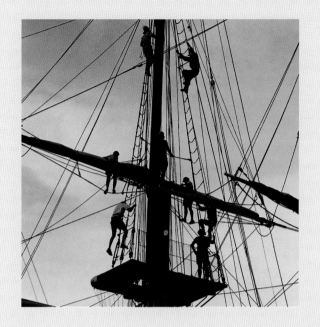

*He is the best sailor who can steer within the
fewest points of the wind, and extract a
motive power out of the greatest obstacles.*

—Henry David Thoreau (1817–1862)
American essayist, poet, and philosopher

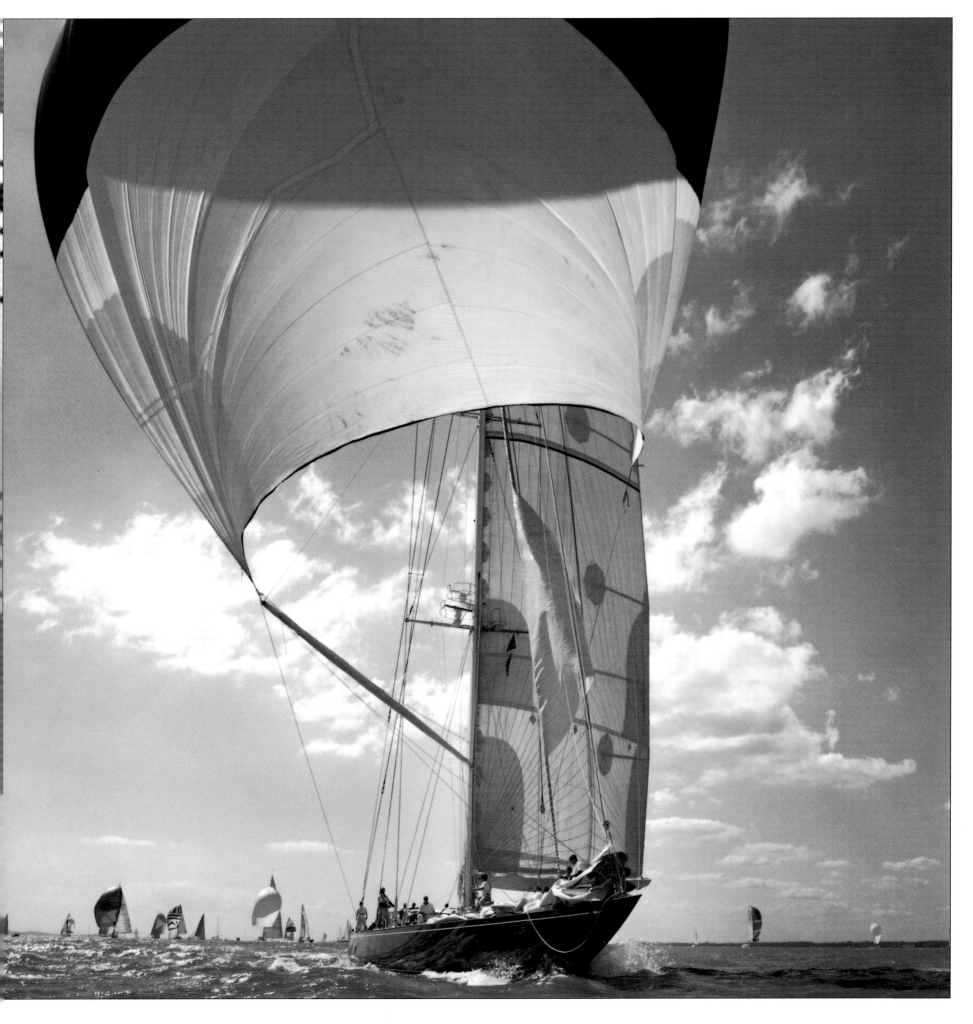

A WET SHEET AND A FLOWING SEA,

A WIND THAT FOLLOWS FAST

AND FILLS THE WHITE AND RUSTLING SAIL

AND BENDS THE GALLANT MAST.

— Allan Cunningham (1784–1842)
Scottish poet

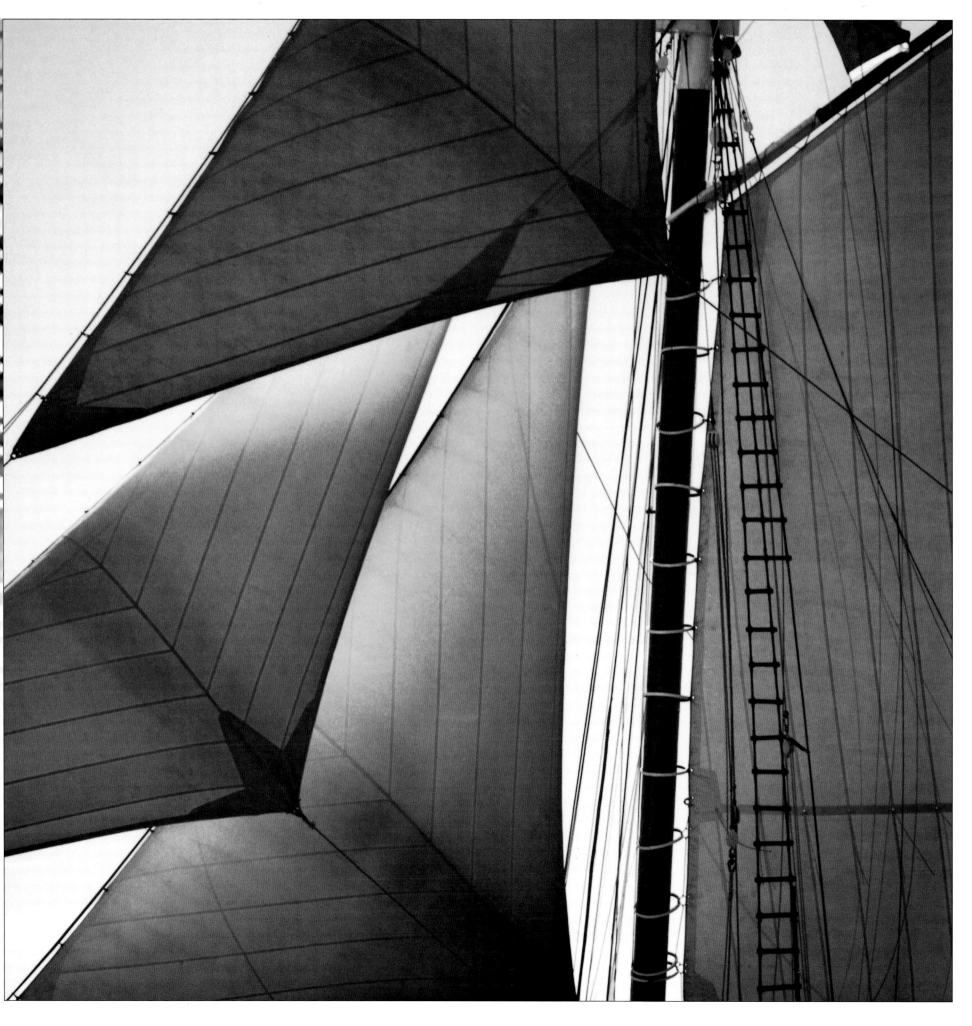

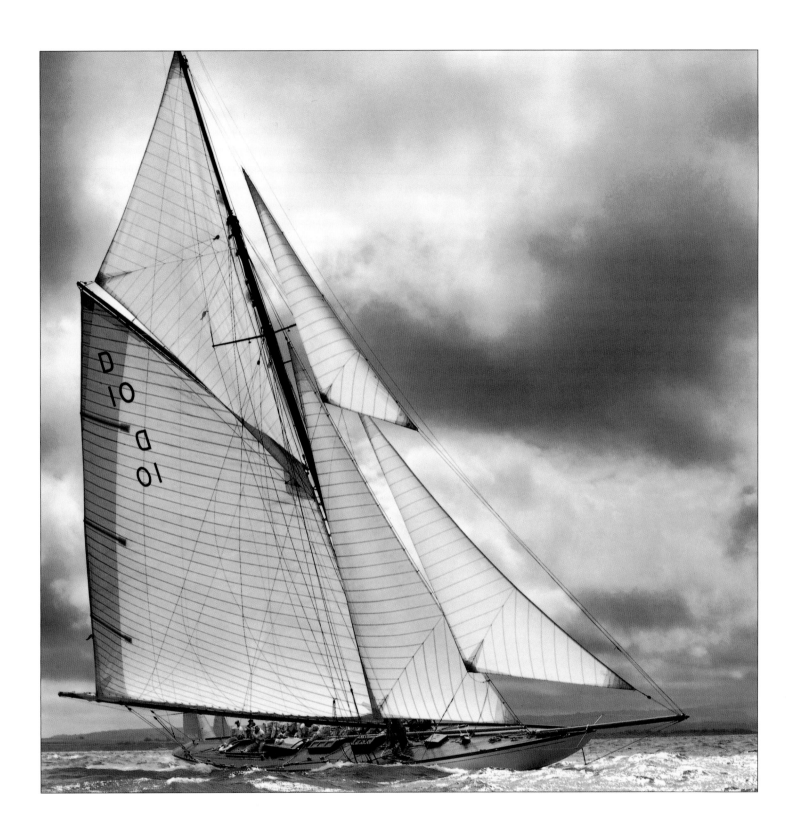

THE HUMAN HEART IS LIKE A *ship* ON A STORMY *sea* DRIVEN ABOUT BY WINDS BLOWING FROM ALL FOUR CORNERS OF *heaven*.

—MARTIN LUTHER (1483–1546)
GERMAN CLERIC

I find the great thing in this world is not so much where we stand, as in what direction we are moving; to reach the port of heaven, we must sail sometimes with the wind and sometimes against it—but we must sail, and not drift, nor lie at anchor.

OLIVER WENDELL HOLMES
(1809–1894)
AMERICAN WRITER AND POET

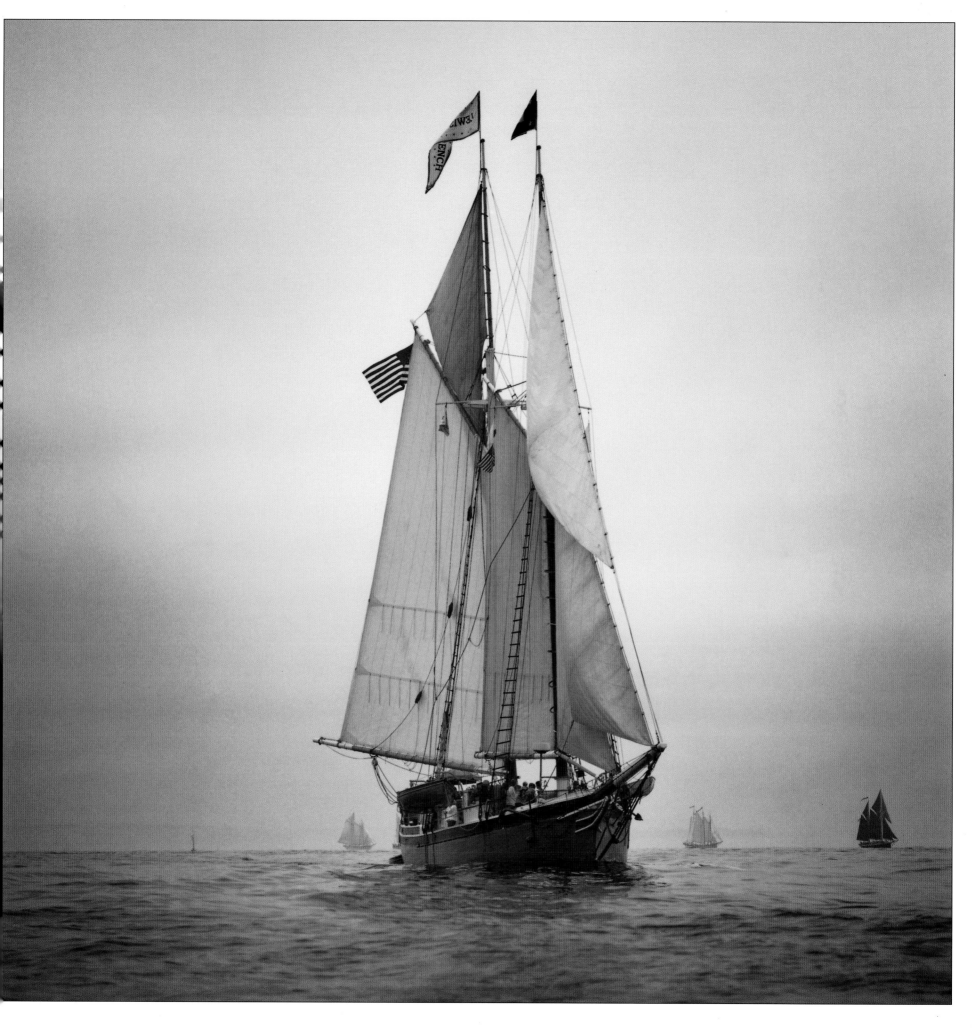

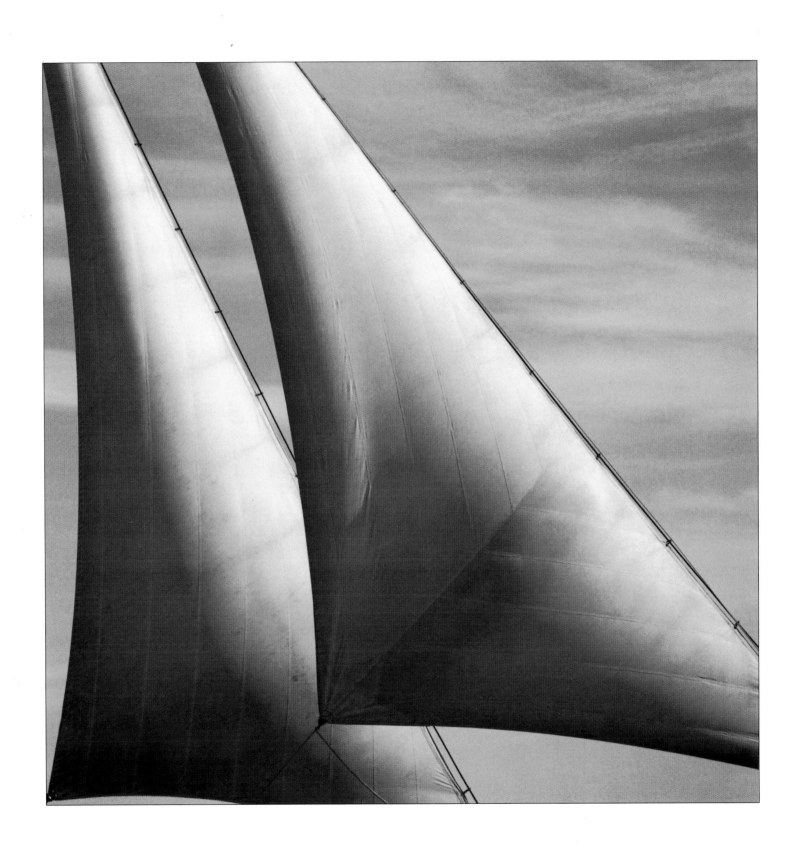

There are no waves without wind.

—CHINESE PROVERB

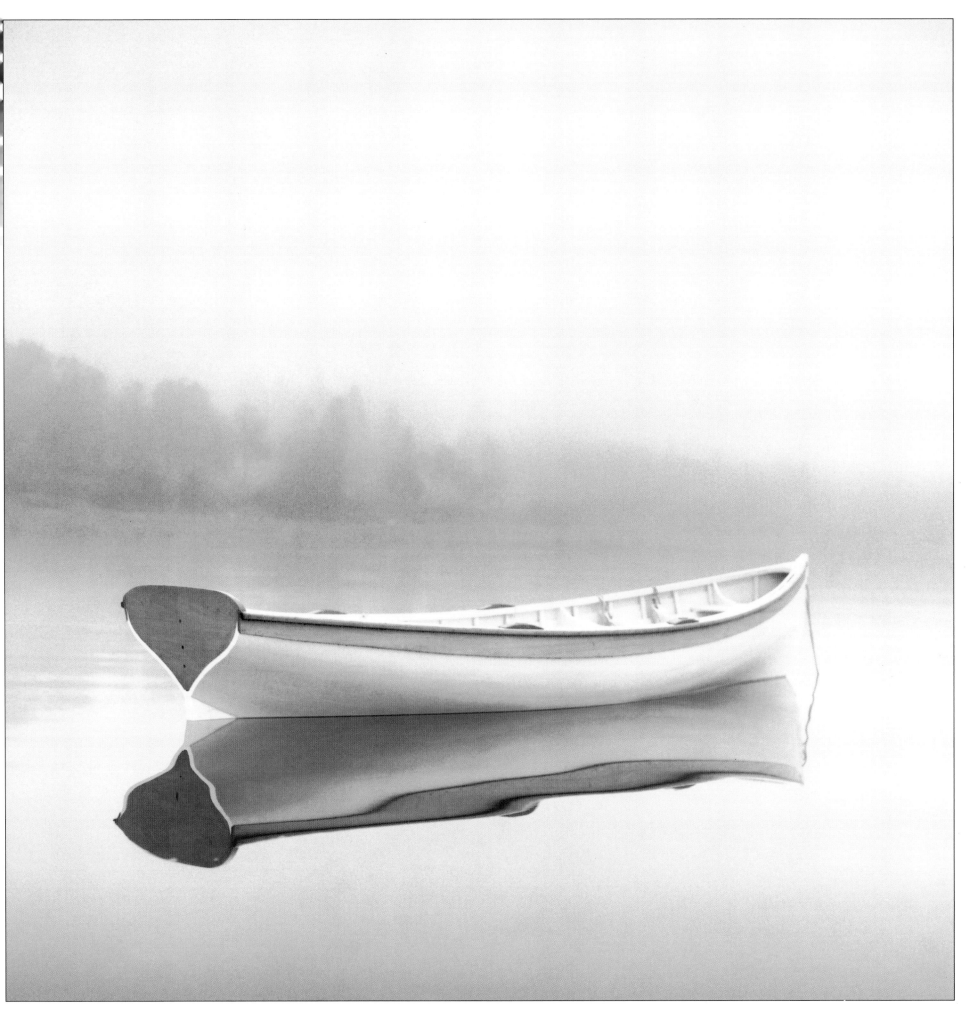

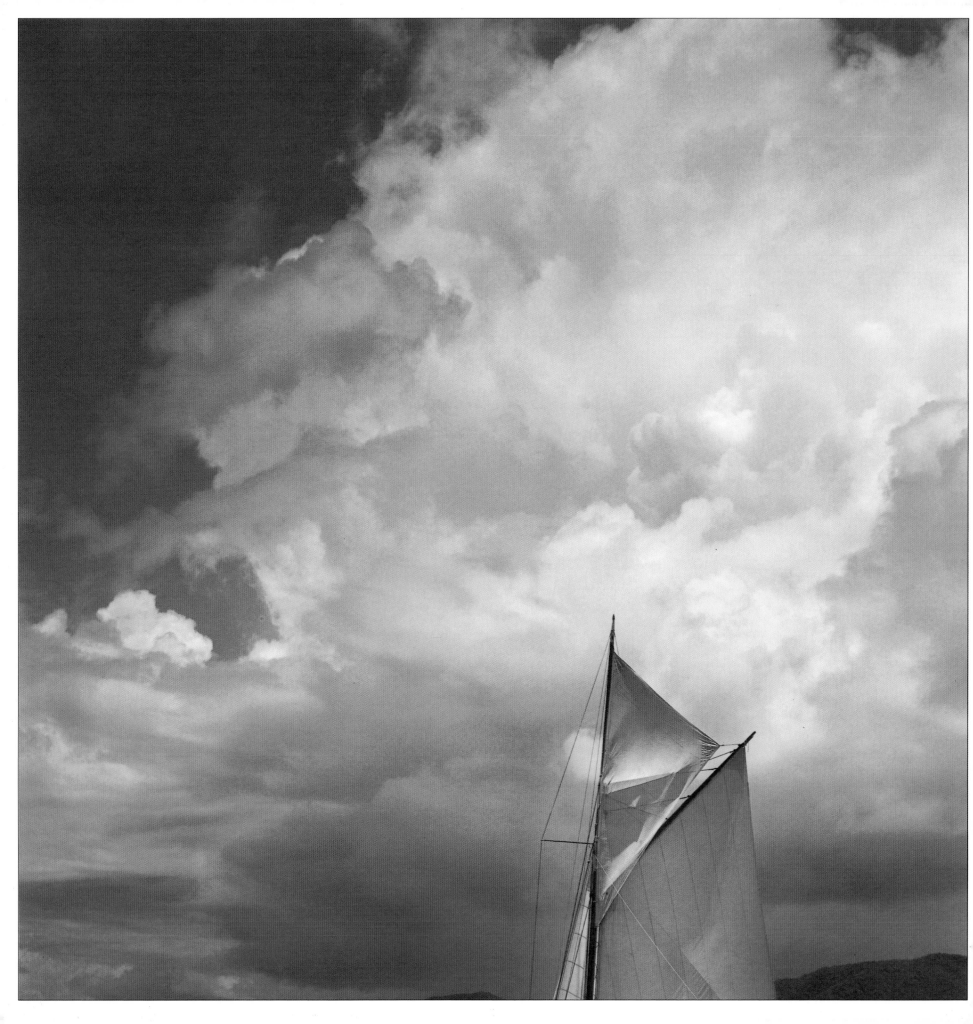

WIND SPEEDS HER,

BLOWING UPON HER HANDS

AND WATERY BACK.

SHE TOUCHES THE CLOUDS, WHERE SHE GOES

IN THE CIRCLE OF HER TRAVERSE OF THE SEA.

—From "The Paltry Nude Starts on a Spring Voyage"
Wallace Stevens (1879–1955)
American poet

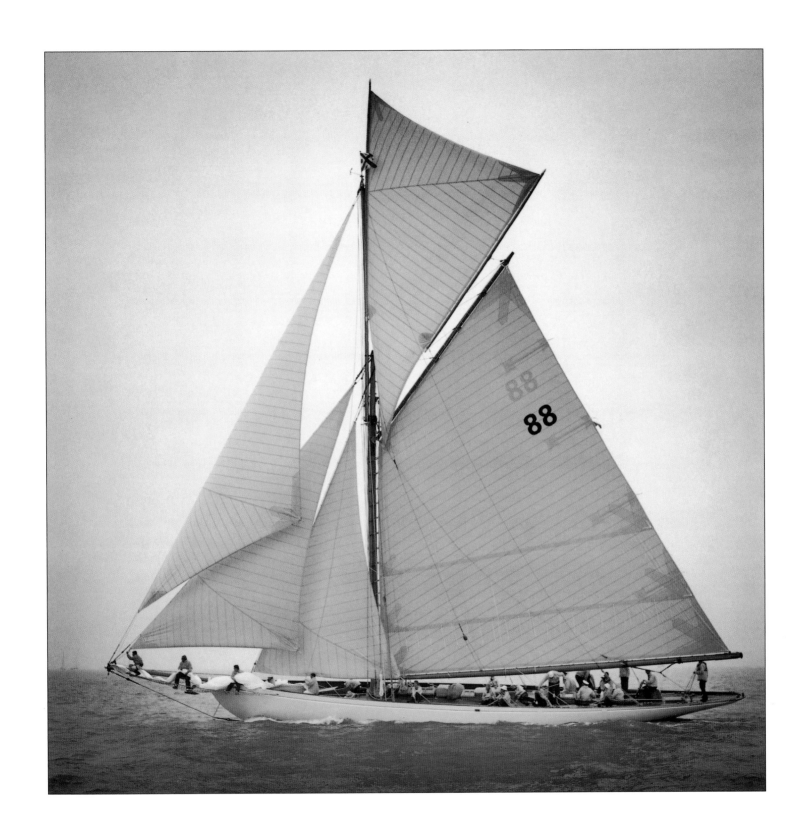

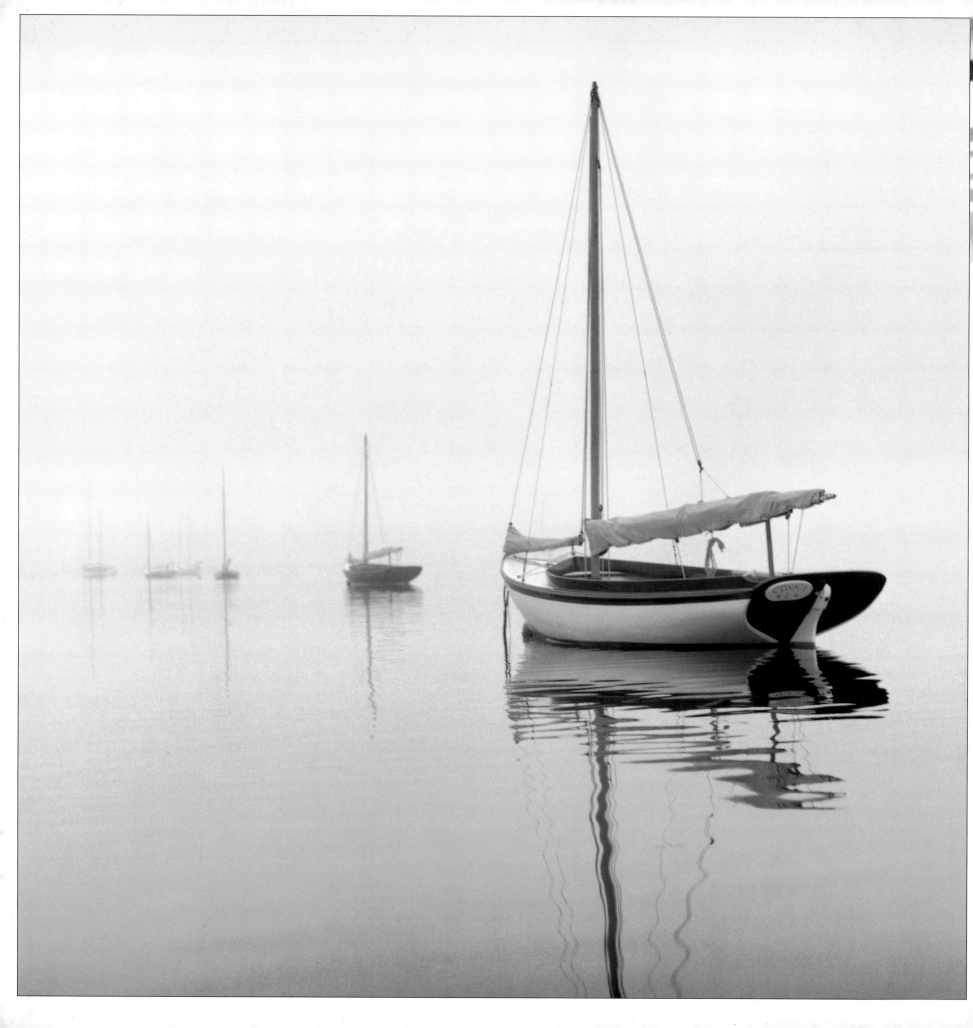

HEALTH, SOUTH WIND, BOOKS, OLD TREES, A *boat*, A FRIEND.

—RALPH WALDO EMERSON (1803–1882)
AMERICAN ESSAYIST, POET, AND PHILOSOPHER

A SAILOR IS AN ARTIST WHOSE MEDIUM IS THE WIND.

—Webb Chiles (20th Century)

American sailor and writer